IMAGES
of America

GREAT YACHTS
OF LONG ISLAND'S
NORTH SHORE

ON THE COVER: *Saga* was a violin that went into the water. Designed and built by Wheeler in 1935 for Charles S. Payson of Manhasset, the 69 feet of varnished mahogany was powered by V12 engines—first Packards and then 600-horsepower Wright Typhoons. *Saga* was a fast "commuter," the type of swift and graceful yacht that whisked Wall Streeters into work every day from the North Shore. (Mariners' Museum.)

IMAGES
of America

GREAT YACHTS
OF LONG ISLAND'S
NORTH SHORE

Robert B. MacKay

ARCADIA
PUBLISHING

Copyright © 2014 by Robert B. MacKay
ISBN 978-1-4671-2152-1

Published by Arcadia Publishing
Charleston, South Carolina

Printed in the United States of America

Library of Congress Control Number: 2013950193

For all general information, please contact Arcadia Publishing:
Telephone 843-853-2070
Fax 843-853-0044
E-mail sales@arcadiapublishing.com
For customer service and orders:
Toll-Free 1-888-313-2665

Visit us on the Internet at www.arcadiapublishing.com

CONTENTS

ACKNOWLEDGMENTS

Many of the images in this book were taken by the two great maritime photographers of their day: Edwin Levick, an English émigré who came here to translate Arabic for a New York bank but soon found other opportunities; and one of his assistants, Morris Rosenfeld, who was to start his own firm in 1910. Happily for the pastime, their collections survive. This book would not have been possible without the assistance of Claudia Jew at the Mariners' Museum in Newport News, Virginia, where the Levick collection is housed, and MaryAnn Stets and Louisa Watrous at Mystic Seaport in Connecticut where the nearly one million Rosenfeld images are located. Thanks are also due to Jean Gamble of Historic New England's N.L. Stebbins Collection, Elly Shodell of the Port Washington Library, Karen Martin of the Huntington Historical Society, Carol Stern and Elizabeth Cameron at the Glen Cove Public Library, Stephanie Gress of the Suffolk Country Vanderbilt Museum, Sandy Branciforte at SPLIA, Vanessa Cameron and Alice Dickinson at the New York Yacht Club, Jon M. Williams at the Hagley Museum and Library, and Paul J. Mateyunas. Thanks also to descendants of the yachtsmen who assisted in this effort, including Finlay Matheson, John R. Pflug, Henry H. Anderson, and the late Ann Hester Kennedy. The images appearing in the book are courtesy of the following institutions and publications:

Architect and Builders Magazine (AB)
Authors collection (AC)
Arts & Decoration (AD)
American Homes of Today (AHT)
Architectural Record Magazine (AR)
Country Life in America Magazine (CLA)
Frederick Law Olmsted National Historic Site (FLO)
Huntington Historical Society (HHS)
Hagley Museum and Library (HML)
Hicks Nurseries Collection (HN)
Historic New England (HNE)
King's Notable New Yorkers (K)
Library of Congress (LC)
Manhasset Bay Yacht Club (MBYC)
Monograph of the Work of Charles A. Platt (MCAP)
Museum of the City of New York (MCNY)
Mariners' Museum (MM)
Mystic Seaport, Rosenfeld Collection (MS)
Nassau County Museum (NCM)
National DeFence Hq., Ottawa, Canada (NDH)
Noted Long Island Houses (NLH)
North Shore Science Museum (NSSM)
Private Collection (PC)
Kenneth Brady Collection, Port Jefferson Village Historian (PJ)
Port Washington Library (PWL)
The Rudder (R)
Richard J. Reynolds, Historian, Glen Cove Yacht Club (RR)
Suffolk County Vanderbilt Museum (SCVM)
Seawanhaka Corinthian Yacht Club (SCYC)
Society for the Preservation of Long Island Antiquities (SPLIA)
SPUR (SPUR)
Town and Country Magazine (TC)
Tiller Publishing (TP)

INTRODUCTION

The desire of Manhattan's affluent to build country houses on Long Island and participate in the new forms of recreation and leisure becoming popular at the turn of the 20th century transformed the region in the era from the 1890s to World War II. The *Brooklyn Daily Eagle* thought Long Island had been "touched by magic, a new version of the Sleeping Princess." While the equestrians gravitated toward Wheatly Hills and Old Westbury, members of the country house set who agreed with Mole in Kenneth Grahame's *The Wind in the Willows* that there is nothing so much fun as messing around in boats, chose the shore. An additional advantage for those who built between Great Neck and Eaton's Neck, the so-called Gold Coast, was a new mode of commuting. "An enormous fleet of private yachts" regularly plies Long Island Sound's waters, the *New York Herald* observed in 1902, carrying owners "at racing speeds twice a day from their great estates to the wharf on Manhattan Island nearest their offices." The seasonal phenomenon would soon lead to a whole new class of yachts variously known as "commuters," or "business boats." For many, one yacht would not be enough; a small fleet was required to take advantage of all the possibilities offered by the new pastime. Moving east, apace with the yachtsmen, were their clubs, providing the facilities, regattas, and opportunities for social interaction. Momentous for the North Shore was the decision of the Seawanhaka Corinthian Yacht Club to build a clubhouse at Centre Island in Oyster Bay in 1892 and the Douglaston Yacht Club's move to Port Washington in 1899, after which it became the Manhasset Bay Yacht Club. The New York Yacht Club established a "station," or branch, at Glen Cove in the 1890s and then barged its original clubhouse there from Hoboken in 1904. Although Seawanhaka, the leading "Corinthian" (amateur) yacht club, had been founded in Oyster Bay 20 years earlier by young men of its summer colony, it was a city institution with a townhouse in Manhattan and a station at Staten Island. Following the completion of the new clubhouse, nine members had built country houses on Centre Island. More than 30 were in the vicinity by 1932. The Manhasset Bay Yacht Club's propitious move would lead to a new clubhouse by 1902 closely resembling Seawanhaka and a five-fold increase in membership. Station 10, as the New York Yacht Club's outpost was known, quickly became popular not only as an anchorage and an assembly point, but as a place to board commuters headed for its station at Twenty-sixth Street on the East River, where many of the business boats docked during the day.

At other places along the North Shore, particularly where there were summer colonies and a need for facilities, local yacht clubs were formed. The Huntington Yacht Club, for example, was organized in 1894 by both summer and year-round residents and included on its membership rolls such distinguished yachtsmen and country house owners as the mining and pharmaceutical magnates August Heckscher, Frederick L. Upjohn, and George McKessen Brown. Juliana Armour Ferguson, a prominent early yachtswoman, was also a member. By 1939, when *Fortune* called the region a yachting paradise, there were 17 yacht clubs from Little Neck Bay east to Northport. Wherever there was a bay, there were clubs. At Manhasset Bay, in addition to the Manhasset Bay Yacht Club, were the Knickerbocker (1874), another club that had moved east from the city; Port Washington Yacht Club (1905); and the Plandome Field and Marine (1908). At Hempstead Harbor were two of the North Shore's oldest, both organized in 1891, the Sea Cliff and Hempstead Harbor Yacht Clubs. Farther east, noteworthy clubs included the Cold Spring Harbor Beach Club (1924), Huntington's Ketewomoke (1913), the Northport Yacht Club (1908), and also at Northport, the Independent Yacht Club. The North Shore was also the venue for all sorts of on-the-water events, including national and international competitions during the golden age of yachting.

While the America's Cup match races between the defending American yacht and a foreign challenger took place in the ocean off Sandy Hook, the huge sloops that were defense candidates were often seen in trials and races along the North Shore.

The international competitions in the Six Meter Class off Oyster Bay between the wars were closely followed by the press and brought some of the world's best sailors to the North Shore. The British-American Cup of 1922, the first international team race sailed on American waters,

attracted so much public attention that when the series returned two years later, the Navy had to dispatch three four-stack destroyers to control the spectator fleet as steamers with brass bands followed the contestants around the course. In 1927, the Scandinavian Gold Cup attracted the largest fleet of foreign yachts that had ever competed in this country—including the winner, which was owned by Crown Prince Olaf of Norway. Hollywood soon picked up on the glamour in the 1937 film *Nothing Sacred*, a David Selznick production staring Carole Lombard and Frederic March that included a Six Meter sailing up the East River.

Two of the nation's oldest yachting competitions originated on the North Shore. The Seawanhaka Cup, presented in 1895 for an international match race series in small boats, and the Manhasset Bay Challenge Cup, first competed for in 1903, are still actively raced for today.

The well-protected bays of Huntington and Manhasset also proved to be an ideal venue for speedboat racing. The coveted Harmsworth Trophy, officially the British International Trophy for Motorboats, was contested for on Huntington waters in 1908 and then again from 1910 through 1912. The races would be dominated by the Clinton Crane–designed series of *Dixies*. *Dixie IV* set a new world speed record in 1911 of 45.22 miles per hour, breaking the mark set in 1902 by *Arrow*, another boat with a North Shore history. These contests, motorized versions of the America's Cup, attracted large spectator fleets and took place in front of the posh Chateau de Beaux Arts Casino (1905–1907), which was owned by the Bustanoby brothers, the popular Manhattan restaurateurs. Races for the prestigious Gold Cup were held on Manhasset Bay in 1915 and again in 1925 when it was estimated that 1,500 spectator craft anchored along the course together with several floating grandstands.

The North Shore was also the stage for a great naval review off Oyster Bay in 1905 when Theodore Roosevelt, on board the *Mayflower*, steamed past 45 ships of the Atlantic Fleet and the arrival by yacht of the Prince of Wales on his visit to America in 1924. However, the most remarkable spectacle afloat may well have been off Glen Cove when the New York Yacht Club's squadron (fleet) of huge sailing and steam yachts gathered before the start of their Annual Cruise to New England. The Glen Cove rendezvous, which was followed by the press and spectators ashore, brought together many of the yachts pictured in this book.

While a number of the well-heeled captains of finance and industry did not know the bow of a boat from the stern, as Sherman Hoyt would say of his father, a surprising number of these business leaders or their sons and daughters became proficient amateur sailors. There was no better example than Sherman, who would become a naval architect and one of the nation's leading sailors credited with saving the America's Cup in 1934. Arthur Curtis James, J. Rogers Maxwell, and Herman B. Duryea were among the earlier North Shore yachtsman to take the helm of their own yachts. Later would come a host of others, and at time of war, many served in the Navy.

By 1930, time was making some changes along the North Shore, and it was not just as a result of the stock market crash the previous October. The America's Cup competition, for so long held off New York, moved to Newport that year. The New York Yacht Club's activities were also moving east. Glen Cove would be less used as the rendezvous point for its annual cruise and regattas. And then in 1938, two years after the completion of the Triborough Bridge, providing rapid auto access to Manhattan, the club gave up its docks for commuting yachts at Twenty-sixth Street, bringing the business boat phenomenon to a close. Many of the great yachts seen off the North Shore were taken for naval service during World War II, never to return. George F. Baker's *Viking* sunk off Cape May after being rammed on convoy duty in 1943. Willie K. Vanderbilt's *Alva* and the Harknesses' *Cynthia* were torpedoed and went to the bottom off North Carolina. Though J.P. Morgan's *Corsair IV* survived, he died in 1943. The yacht refitted as a cruise ship sank off Acapulco in 1949, the year the New York Yacht Club sold its Glen Cove property to the city. Station 10, whose very arrival on the North Shore had heralded and facilitated the era of the great yachts, was barged away to Mystic Seaport. Yachting would continue on the North Shore, but the golden age was over.

One

LONG ISLAND'S NORTH SHORE
A YACHTING PARADISE

As the 20th century dawned, the North Shore became ever more accessible through transportation improvements by automobile, rail, and water. Numerous harbors, well-protected anchorages, and unobstructed access to Long Island Sound made the North Shore an ideal venue for the nascent pastime of yachting. It soon became a cradle of international sailing and motorboat competitions, home to some of the nation's most important yacht clubs, whose members' country houses and celebrated yachts stretched for miles. Chapter one surveys the clubs, events, and contests that launched the North Shore's golden age of yachting.

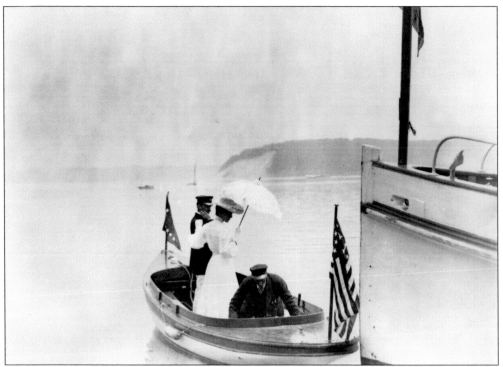

Few photographs convey the elegance and formality of Gilded Age yachting better than this iconic turn-of-the-20th-century view of the Seawanhaka Corinthian Yacht Club anchorage at Oyster Bay, with Coopers Bluff visible in the background. With her parasol raised, a young lady and her yachtsman watch a launch driver attend to his engine. (LC.)

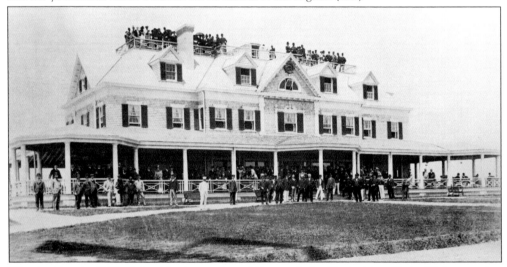

The decision in 1891 of the Manhattan-based Seawanhaka Corinthian Yacht Club to seek a waterfront home on Long Island Sound would prove momentous for the development of yachting on the North Shore. After considering locations closer to the city and in Westchester, the club purchased property at Centre Island in Oyster Bay, the Long Island Rail Road having extended a line there in 1889. The new clubhouse, seen here on opening day in 1892, was designed by R.W. Gibson, an architect and avid canoe sailor. (SCYC.)

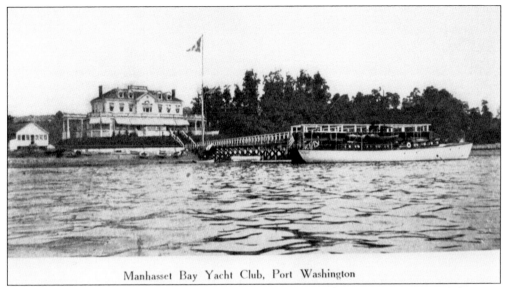

Manhasset Bay Yacht Club, Port Washington

The Douglaston Yacht Club had a compelling reason to move east, lease property at Port Washington, and change its name to the Manhasset Bay Yacht Club in 1899. The previous season, it had not been able to hold races due to mines and torpedoes laid off Fort Totten during the Spanish-American War. By 1901, the club had acquired property and begun construction of its new clubhouse, designed by the distinguished firm of Hoppin & Koen. It closely resembled Seawanhaka. (AC.)

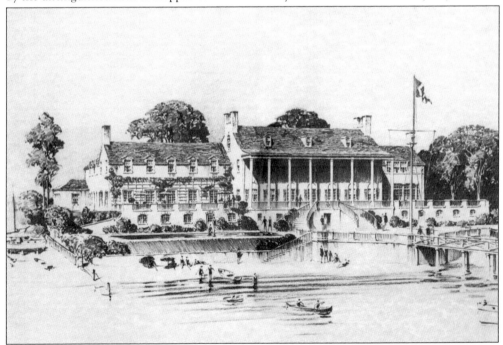

By the late 1920s, Manhasset Bay Yacht Club's membership had doubled and an elegant, new clubhouse designed by Theodore Engelhardt replaced the earlier building in 1929. The club was to play a significant role in the development of the Star Class, the racing keelboat that was an Olympic Sailing class from 1932 to 2012. The club's Manhasset Bay Challenge Cup (1902) is the oldest yachting trophy in the country, competed for annually. (MBYC.)

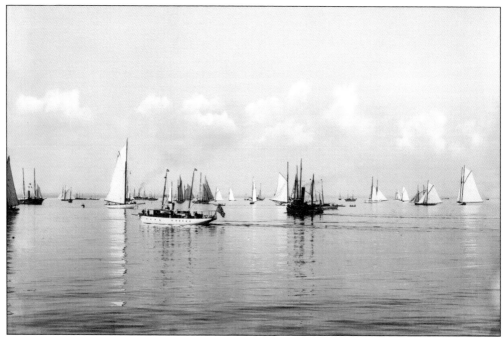

The New York Yacht Club's fleet awaits a breeze off Glen Cove at the start of their annual cruise on August 2, 1897. Western Long Island Sound had become New York's favorite yachting venue by the 1890s, and many drawn to the pastime would soon build country houses along the bluffs and bays of the North Shore. (LC.)

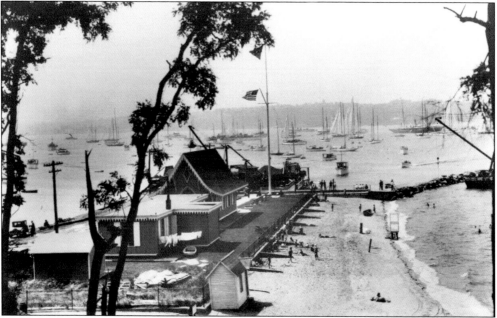

Laundry hangs on line behind the caretakers' quarters at Station 10, the New York Yacht Club facility at Glen Cove, while a portion of its squadron, or fleet of yachts, is seen moored in the background. The large black-hulled yacht at the far right appears to be J.P. "Jack" Morgan Jr.'s *Corsair III*. (MS.)

Station 10 would also prove to be a popular landing place for commuting yachts, or "commuters," as they were called. Making the trip from the city out to Glen Cove in this fashion at the beginning of his celebrated American tour in 1924, was the Prince of Wales (left), seen here just after he boarded the 35-knot express cruiser *Black Watch* from the Cunard liner *Berengaria*. (AC.)

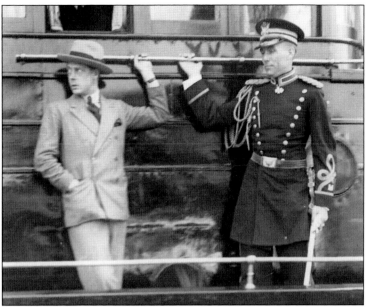

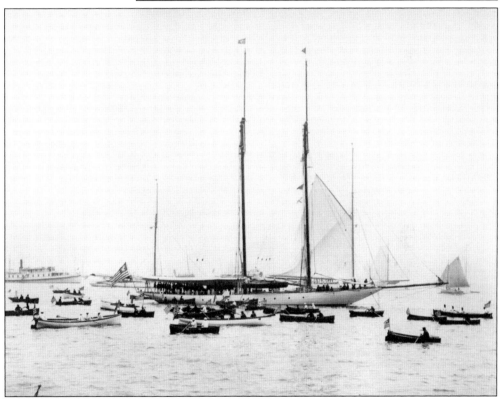

On board Commodore Lewis Cass Ledyard's flagship, *Corona*, at Glen Cove in 1900, a captains' meeting of the yacht owners is under way at the start of the New York Yacht Club's Annual Cruise. Note the pulling boats standing by to shuttle the owners back to their yachts. The commodore's schooner, *Corona*, had begun life as the Herreshoff sloop *Colonia*, an unsuccessful candidate in 1893 to defend the America's Cup. (PC.)

The Glen Cove rendezvous in 1927 of the New York Yacht Club's squadron before their August 15th Annual Cruise to New England was a spectacle not to be forgotten. The first day's run took the fleet to Huntington in a fresh nor'wester. (RR.)

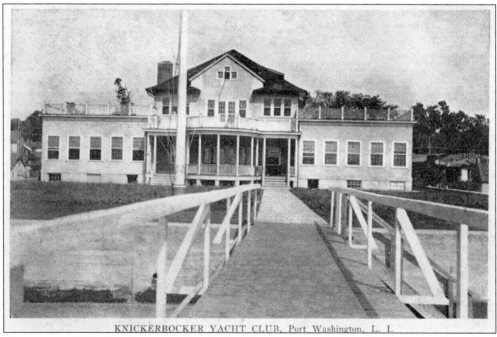

KNICKERBOCKER YACHT CLUB, Port Washington, L. I.

Organized in 1874, the Knickerbocker Yacht Club was yet another club that moved east from the city. It established a station at Manhasset Bay, which was also home to the Port Washington Yacht Club (1905) and Plandome Field and Marine Club (1908). (AC.)

14

Elsewhere along the North Shore, where summer colonies were formed, local yacht clubs sprang up with all the requisite facilities for the new pastime. For example, the Huntington Yacht Club organized in 1894 by both summer folk and year-round residents. Included on its rolls were August Hecksher and pharmaceutical bigwigs Frederick Upjohn and George McKesson Brown. (AC)

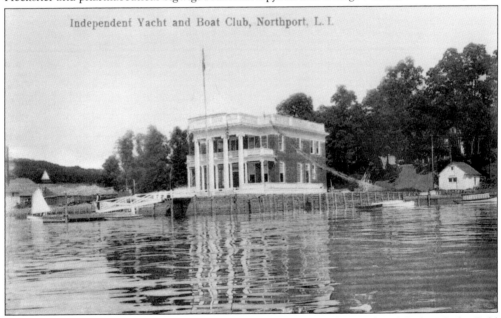

Other early local clubs included the Sea Cliff and Hempstead Harbor Yacht Clubs (1891), the Cold Spring Harbor Beach Club (1924), Huntington Yacht Club (1894), Ketewomoke (1913), Northport Yacht Club (1908), and the Independent at Northport, pictured above. (AC.)

8.30, PUTTING OFF FROM SHORE

COMMUTING
by
MOTOR YACHT

Mr. John W. Kiser commutes from Glen Cove, Long Island to New York daily in his yacht "Fillette"

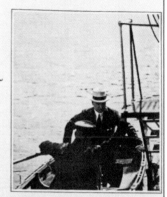

8.35, THE OWNER COMES ABOARD

8.40, THE NEWS BEFORE BREAKFAST

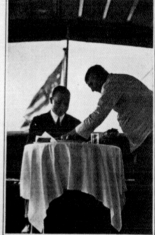

8.45, AL FRESCO BREAKFAST

9.20, A GLIMPSE OF THE CITY

9.30, ASHORE FOR THE DAY'S WORK

47

The opportunity to read the morning papers and breakfast aboard a private water taxi known as a "commuter," or "business boat," while it raced toward the city was why many found this the best way to work. John W. Kaiser's morning commute to the city from Glen Cove aboard his yacht, *Fillette*, was the subject of this photo essay appearing in *Country Life in America* in 1922. (CLA.)

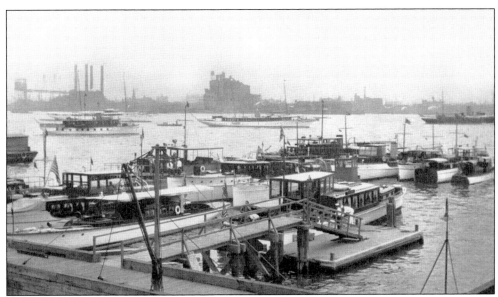

In this 1920s view of the New York Yacht Club's East River landing at the foot of Twenty-sixth Street, commuters—which were in commission from early spring to late fall—are rafted to the pier while the larger yachts anchored in the river were also used for commuting. For those waiting to board their yachts, Station No. 2, as it was known, had a small but stylish Cross and Cross–designed clubhouse with a bar and billiard room. (CLA.)

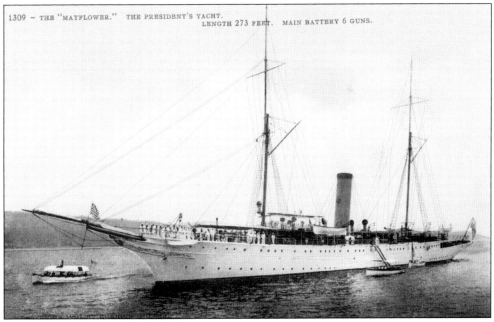

Built in Scotland as a steam yacht for Ogden Goelet, the USS *Mayflower* was purchased by the Navy in 1898 and saw action in the Spanish-American War. Recommissioned and assigned as the president's yacht in 1905, she was at Oyster Bay that year when, at the invitation of Pres. Theodore Roosevelt, envoys to the peace conference ending the Russo-Japanese War met on board. (AC.)

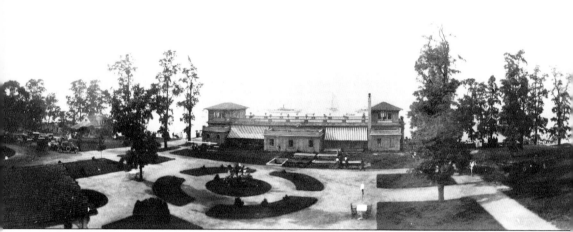

The "cat's meow" of its age, Huntington's Chateau de Beaux Arts was a popular destination for both yachtsmen and "automobilists." Its casino (1905–1907) was designed by the distinguished architectural firm of Delano & Aldrich in association with a French colleague for the Bustanoby brothers, proprietors of Manhattan's fashionable Café de Beaux Arts. (HHS.)

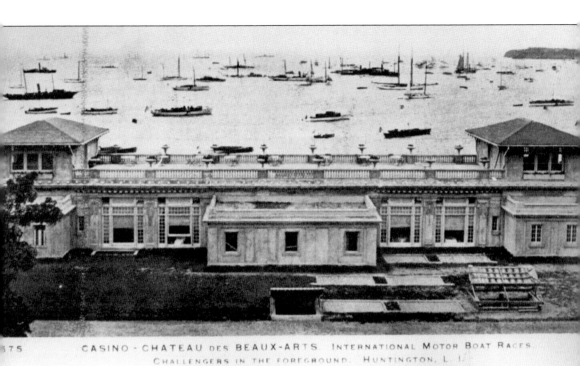

CASINO - CHATEAU DES BEAUX-ARTS. INTERNATIONAL MOTOR BOAT RACES. CHALLENGERS IN THE FOREGROUND. HUNTINGTON, L. I.

The waters in front of the elegant Chateau des Beaux Arts Casino on Huntington Bay were the venue for the International Motor Boat Races, or Harmsworth Trophy, in 1908 and again from 1910 through 1912. The contests attracted a great flotilla of spectator yachts. (SCVM.)

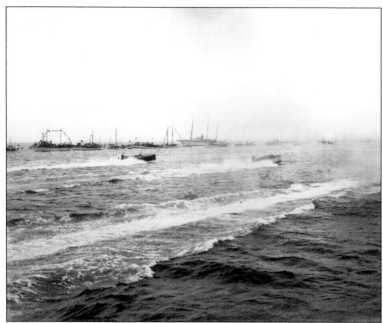

Pioneer, the Duke of Westminster's Fauber-built challenger for the 1910 Harmsworth Trophy competition on Huntington Bay, leads *Dixie II* in front of a large spectator fleet. Powered by a huge 12-cylinder Wolseley-Siddeley engine, *Pioneer* was way ahead until a breakdown left her dead in the water. (MS.)

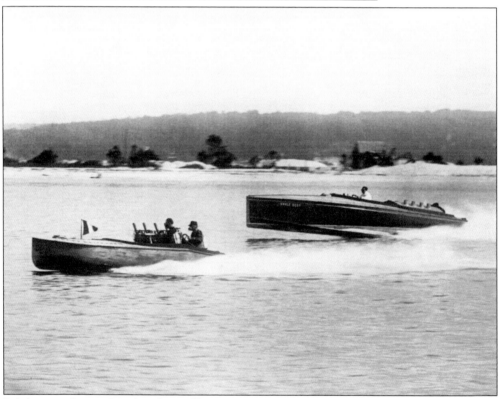

Polish count Casimir Mankowski's *Ankle Deep* trails J. Stuart Blackton's *Baby Reliance II* at the 1912 Harmsworth, with Eatons Neck in the background. Six hundred spectator craft lining the course would watch the hydroplane *Maple Leaf IV* cruise to victory, returning the trophy to England and bringing an end to the international motor boat races on Huntington Bay. (MS.)

Dixie II, the last displacement boat to win the Harmsworth before the appearance of hydroplanes, was designed by Clinton Crane. The versatile naval architect and North Shore resident designed many of the yachts illustrated in this book, including Seawanhaka Cup contestants, Six Meters, the 12 Meters *Seven Seas* and *Gleam*, the steam yacht *Vanadis*, and bark *Aloha*. (MM.)

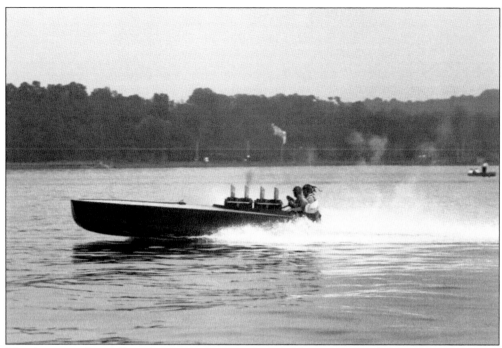

The American Power Boat Association's prestigious Gold Cup was first held on North Shore in 1915. There were 17 contestants for the races on Manhasset Bay, including J. Stuart Blackton's *Baby Reliance V*, seen here. (MS.)

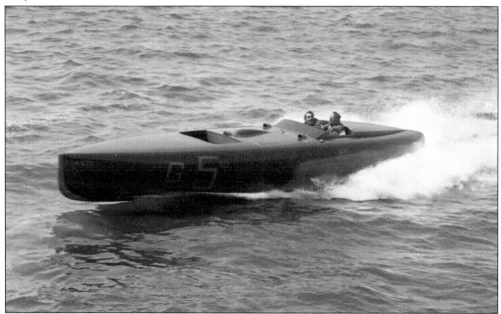

Manhasset Bay again became the national speedboat capital in the mid-1920s when the APBA's Gold Cup races were held there for the first time since 1915. Caleb S. Bragg's *Baby Bootlegger* successfully defended the trophy in 1925; it had won in Detroit the year before in front of the largest fleet of spectator craft that had ever seen such an event on New York waters. In 1926, however, the cigar-shaped speedster was outclassed by a boat from Greenwich, Connecticut. (MS.)

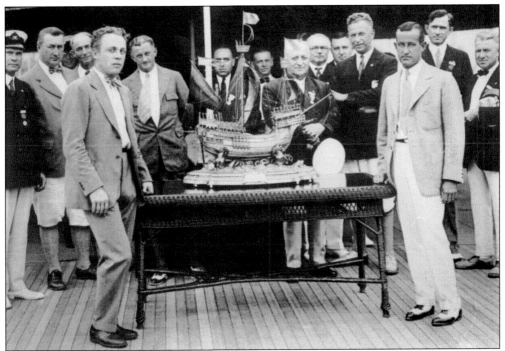

Caleb S. Bragg (1885–1943) is pictured here (right foreground) in 1925 at the presentation of the Dodge Memorial Trophy for a four-heat competition run the day after the Gold Cup. Bragg, who resided in Port Washington at the time, was a Yale-educated inventor, Indy 500 driver, and pioneer aviator. (PWL.)

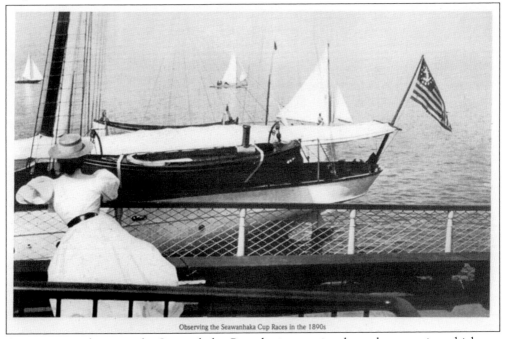

Observing the Seawanhaka Cup Races in the 1890s

A spectator is observing the Seawanhaka Cup, the international match race series, which was off Oyster Bay in the 1890s. (MCNY.)

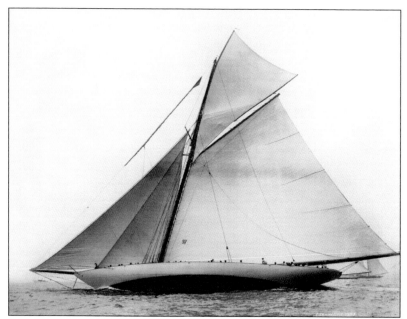

While the America's Cup races before 1930 took place off Sandy Hook, the contestants also appeared in races on Long Island Sound. Pictured here, the 1892 defender *Vigilant* lost her bowsprit and topmast in a race off Lloyd's Neck the following year. (LC.)

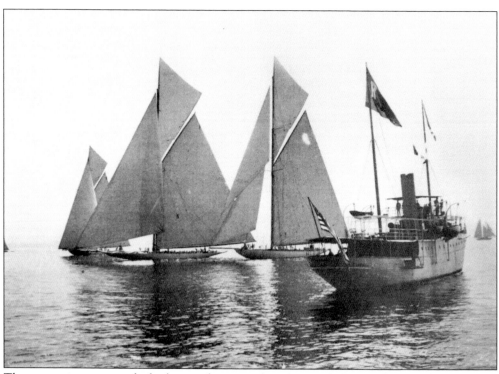

The competitors approach the line at the start of an America's Cup trial race off Matinecock Point on May 26, 1903. The huge sloops *Columbia*, *Constitution*, and *Reliance* were all vying to defend the America's Cup against Sir Thomas Lipton's challenger, *Shamrock III*. *Reliance* won this race and would go on to successfully defend the America's Cup that year. (R.)

24

Resolute, which would defend America's Cup in 1920, is seen here sailing out of Oyster Bay in 1915 with a sailor aloft and Cooper's Bluff on Cove Neck in the background. The 103-foot, Herreshoff-built sloop was racing another defender candidate, *Vanatie*, at the time. (MS.)

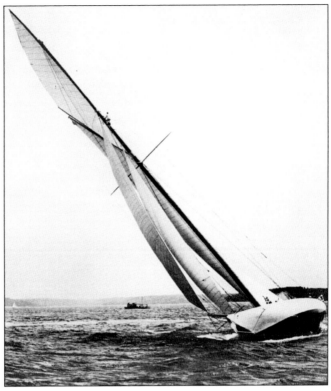

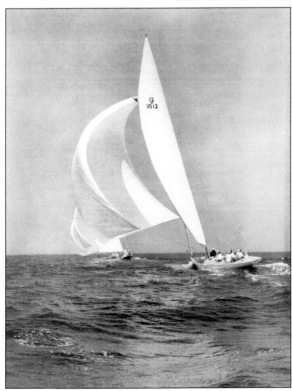

Oyster Bay was the venue for Twelve Meter Class racing before World War II. When the America's Cup resumed off Newport in 1958, the Twelves were chosen for that competition. Seen at left, F.T. Bedford's *Nyala* (US 12) trails Alfred Loomis's *Northern Light* (US 14) and a third competitor in 1938. Other local boats built in the 1930s and designed by either Clinton Crane, who owned *Gleam* (US 11), or Olin Stephens, included H. Vanderbilt's *Vim* (US 15) and V.S. Merle-Smith's *Seven Seas*. W.A.W. Stewart's *Iris* had been built in Germany. (MM.)

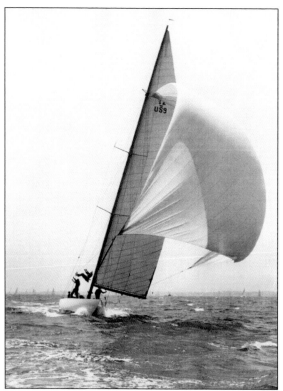

The *Seven Seas* crew resorts to acrobatics to adjust the spinnaker guy in a fresh breeze on Long Island Sound. Designed by Clinton Crane for Van S. Merle-Smith in 1935, she was the first of the American-built Twelve Meters. Merle-Smith, an attorney turned investment banker who would later serve on Gen. Douglas MacArthur's staff in the Pacific, owned Evergreens, a Victorian country house on Cove Neck. (MM.)

Goose, owned by George Nichols, J.P. Morgan's son-in-law, was a phenomenally successful Six Meter designed by Olin Stephens in 1938 that could win races under any conditions. She was close to unbeatable in the international competitions leading up to World War II. *Llanoria*, a near duplicate, also designed by Stephens, won gold medals at the 1948 and 1952 Olympics with Seawanhaka's "Swede" Whiton at the helm. (MM.)

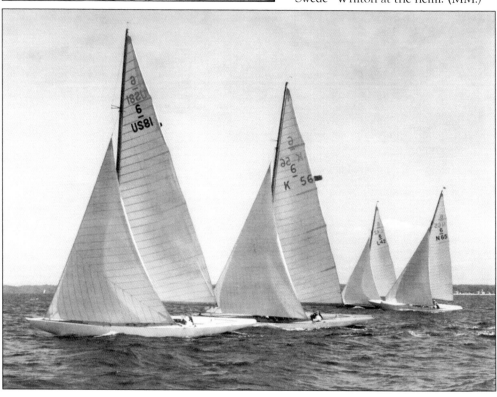

Two

Great Yachts and Estates
Great Neck to Lattingtown

Organized geographically, chapter two surveys the great yachts, their owners, and waterfront estates from Great Neck east along the North Shore to Lattingtown. Alas, there were many more yachts and estates than could be included in this book. Hence, emphasis has been placed on some of the most interesting stories. It is difficult to measure something as nomadic as yachts, but the Lloyds Yacht Registers indicate that even as early as 1918, there were more than 100 yachts with an overall length of 50 feet or more that could be found in anchorages along the North Shore or whose owners were members of clubs there and probably visited during the season. Dozens of yachts were over 100 feet in length, which was no surprise given that 21 of the 55 captains of industry and finance who were profiled by B.C. Forbes in his 1917 best seller *Men Who Are Making America* either resided on Long Island or had children here for part of the year. Period atlases identify more than 200 summer places or estates along the water on the North Shore beyond the existing villages, and the profusion of docks was yet another indication of the popularity of yachting. On Centre Island, the estate owner's new docks actually led to a conflict with the bayman harvesting shellfish by cart and led to the construction of an unusual feature: drawbridges.

If the captains of industry had a general, it was Alfred P. Sloan (1875–1966), president and chairman of General Motors and an authority on management. He and his wife, Rene, are pictured here in 1929 at the launching party for their yacht, the *Rene*. (HML.)

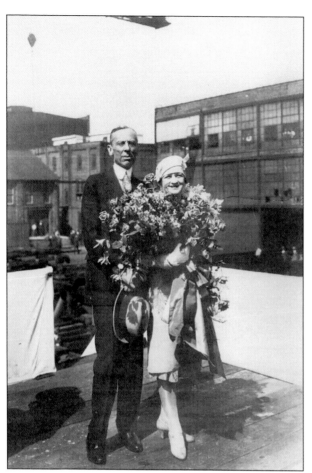

In this extraordinary October 15, 1929, image of the Pusey and Jones Corporation shipyard in Delaware, just weeks before the stock market crashed, large motor yachts are lined up as if they had just come off an assembly line. *Rene*, seen here in the middle, was 236 feet and required a crew of 43. (HML.)

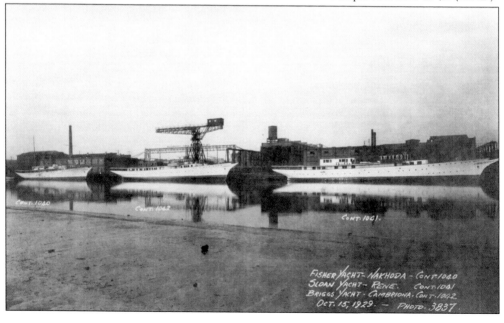

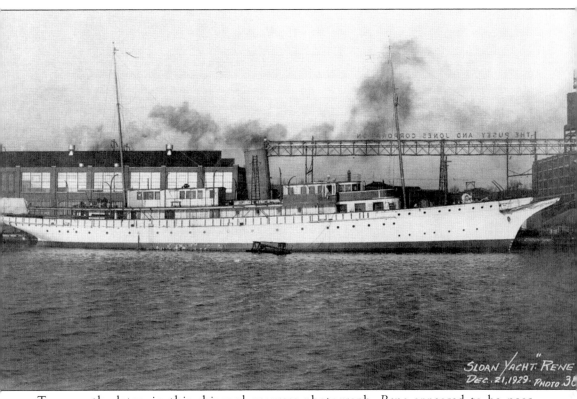

Two months later, in this shipyard progress photograph, *Rene* appeared to be near completion. (HML.)

Although often moored off the New York Yacht Club's station at Glen Cove, which was not far from Sloan's Kings Point residence, Snug Harbor (Walker & Gillette architects, c. 1916), he was to lose interest in the *Rene* (the yacht, not the wife!), which he had reportedly spent $1 million to build. She was seldom used and then usually by relatives until Sloan sold it to the US Maritime Commission in 1941. (AHT.)

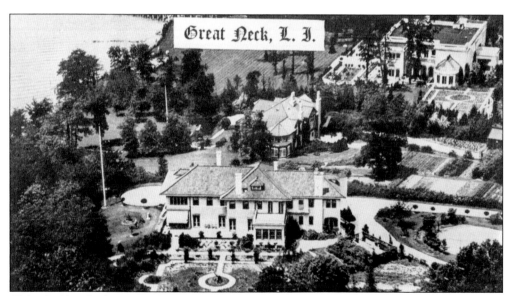

Great Neck, L. I.

Walter P. Chrysler (1875–1940) could see his Manhattan skyscraper rising from his waterfront estate at Kings Point (upper right), which he acquired from Henri Bendel in 1923. The house survives as Wiley Hall, the administration building at the US Merchant Marine Academy. (CLA.)

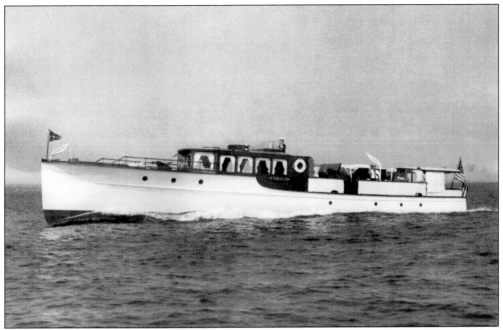

Frolic III, the final commuter commissioned by Chrysler, was designed by John H. Wells, who had been responsible for some of the most beautiful "business boats" and built by Mathias of Camden, New Jersey, in 1927. The elegant yacht was not a speed demon but could move right along at 30 miles per hour with a pair of eight-cylinder Winton engines. (MM.)

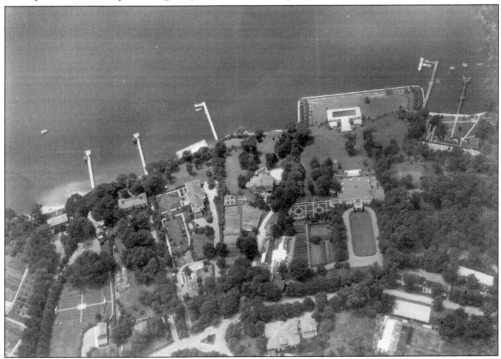

In this aerial view of Kings Point from the 1930s, Chrysler's estate with its oval drive, residence, and pool is seen right of center. *Frolic III* is also visible at the dock on the far right. (SPLIA.)

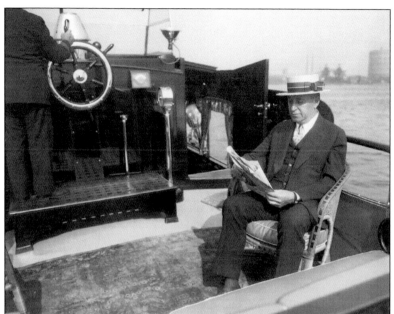

Chrysler is seen here in business attire aboard *Frolic III* on his daily commute to the city. (MS.)

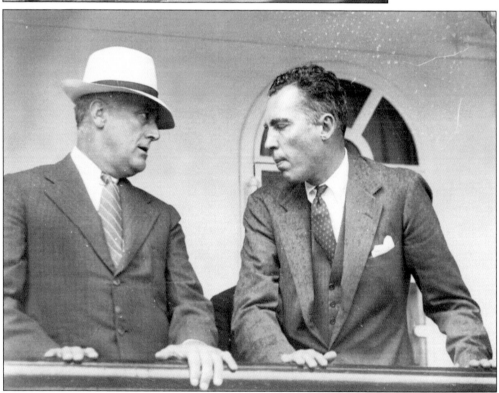

Although his father had gone down on the *Titanic*, Vincent Astor (right), heir to a Manhattan real estate fortune, embraced the sea. He served as an officer in the US Navy during both world wars and was commodore of the New York Yacht Club when he built his magnificent flagship *Nourmahal* in 1928. His close friend, Franklin Delano Roosevelt (left), was a frequent guest and is seen here at the America's Cup in 1934 (AC.)

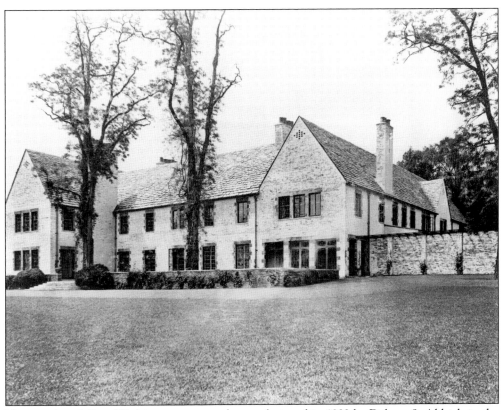

Vincent Astor's Port Washington country house, designed in 1922 by Delano & Aldrich in the English Arts & Crafts mode, was not far from the New York Yacht Club's Station 10 at Glen Cove. Astor served as commodore of the club from 1928 to 1930. (NCM.)

Built by Krupp in Germany, *Nourmahal* was the third Astor family yacht to be so named. Powered by diesels, she was 262 feet overall and had more the appearance of a cruise ship than a pleasure yacht. (MM.)

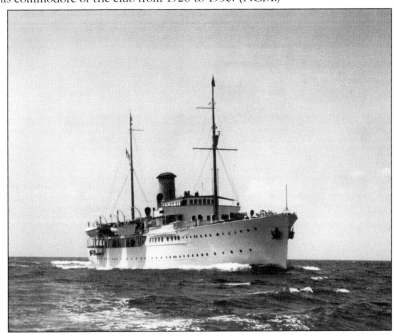

Inside *Nourmahal*'s pilothouse, her binnacle, wheel, telegraph, chronometer, barometer, and chart table were all close at hand. (MM.)

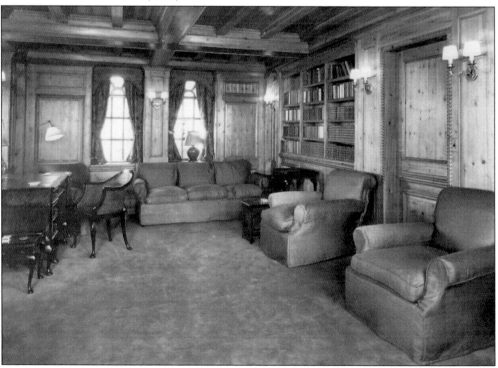

Nourmahal's paneled library could have been designed for a Park Avenue apartment. (MM.)

A painter stands under one of
Nourmahal's huge propellers while
the yacht is in dry dock. (MM.)

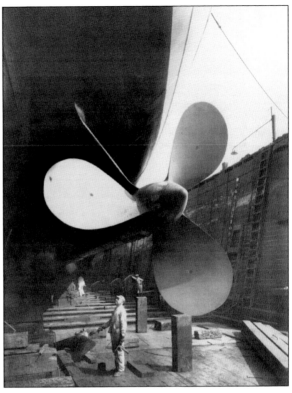

Howard Gould (1871–1959), son of the
controversial railroad and financial
tycoon, was a steam yacht racing
enthusiast and donor of the Niagara IV
Cup, for such competitions, to the New
York Yacht Club. In 1902, he and his
wife purchased property for their estate,
Castle Gould, at Sands Point. (AC.)

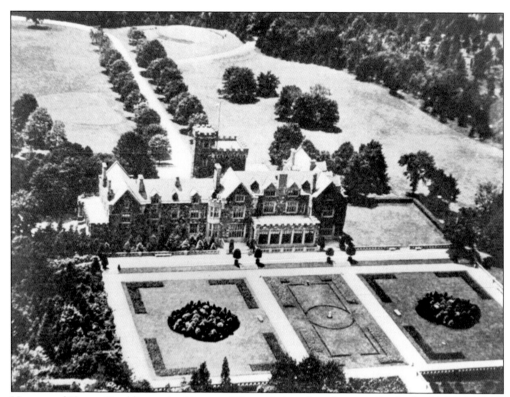

Hempstead House, Gould's massive Hunt and Hunt–designed residence at Castle Gould (1909–1911), was a veritable granite fortress. However, interest in steam yacht racing was already on the wane when the work began, and Gould's marriage had ended in divorce in 1907. By 1917, he would sell the estate to Daniel Guggenheim. (AD.)

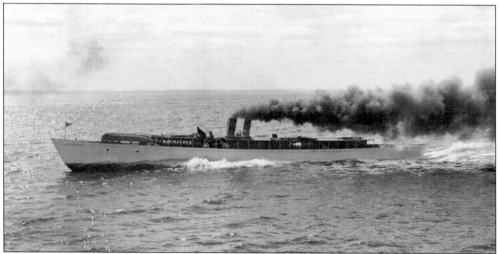

Niagara IV, Gould's 112-foot flyer, engaged in some exciting and much publicized match races with Willie K. Vanderbilt's Tarantula along the North Shore. In 1904, Niagara IV won a 39-mile contest from Stepping Stones Lighthouse to Eaton's Neck and back, passing Vanderbilt craft off Matinecock Point on the first leg. However, the following year, Tarantula was the victor in a race from Crane's Neck to Wading River. (MS.)

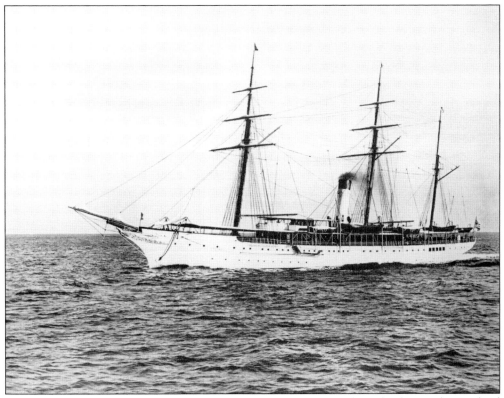

Also named *Niagara* were Gould's other yachts: a 65-foot Herreshoff sloop that he raced in England in 1895 and the magnificent 272-foot, twin-screw bark seen here. Built in 1898 by Harlan & Hollingsworth of Wilmington, Delaware, the three-masted vessel boasted Renaissance Revival interiors and was one of the most opulent yachts of her era. (MM.)

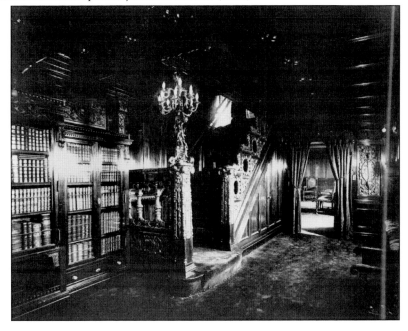

This well-known Gilded Age image shows the library and staircase aboard *Niagara*. (MS.)

John Hay "Jock" Whitney (1904–1982), the publisher of the *New York Herald Tribune* and ambassador to the United Kingdom during the Eisenhower administration, and his wife, Liz, dance together in 1940. Whitney had his hand in aviation, theater, movies, polo, horse racing, art, philanthropy, education, and other interests and did them all well. (AC.)

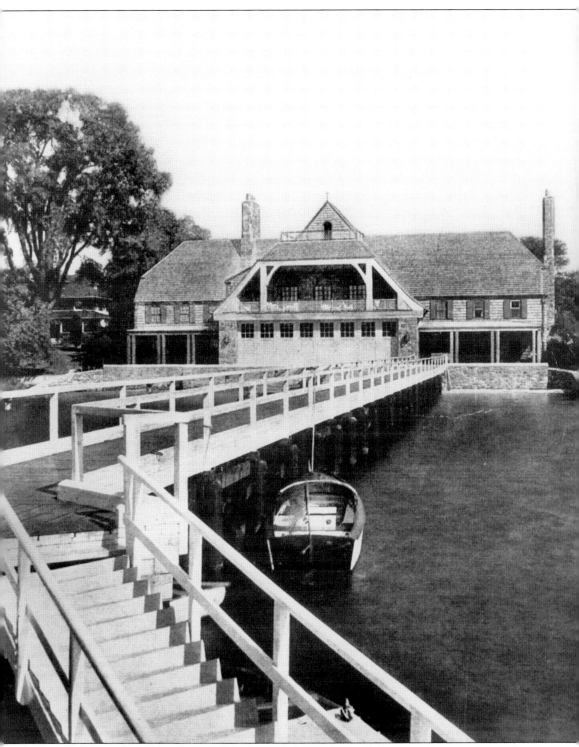

Jock Whitney's handsome Arts and Crafts–style boathouse on Manhasset Bay was designed not only to house small craft, but an amphibious airplane with a 40-foot wingspan. (SPUR.)

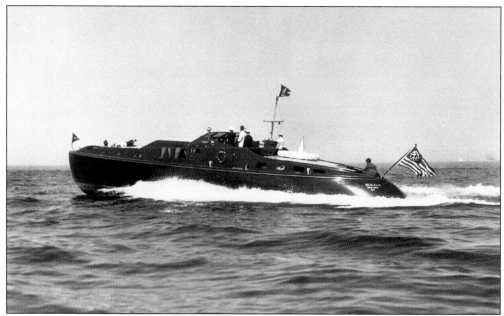

Machine-age expressions of streamlining afloat, commuters *Saga* (above) and *Aphrodite* (below) were owned by the brothers-in-law John Hay Whitney and Charles S. Payson, respectively. Launched in 1935 by Wheeler, the 70-foot *Saga* cost $88,000, a record for a boat its size. At 44 knots, she burned a prodigious amount of fuel. Stopping for gas at Gloucester en route to Maine, Payson was surprised to see a crowd . . . the fuel dock's creditors who heard *Saga* coming. (MM.)

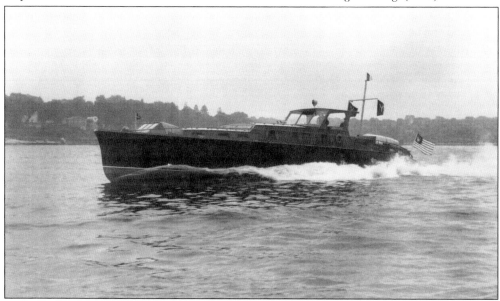

Aphrodite (1936–1937), with her clipper bow and torpedo boat stern, was perhaps the most beautiful commuter ever created and one of the few still extant. Shirley Temple had a birthday party on board, and her guest list during the Whitney era included Fred Astaire, Vivien Leigh, Helen Hayes, Spencer Tracy, Katherine Hepburn, and Joan Crawford. During World War II, she was used to run dispatches up to FDR at Hyde Park and as a chase boat for PT boat trials when powered with Packard V12s enabling her to attain a speed of 54 miles per hour. (MM.)

Aphrodite was built to beat *Saga* by the Purdy Boat Company, who moved to Port Washington in 1926. The talented brothers, Gilbert and Edward Purdy, had a great patron in Carl Fisher, developer of Miami Beach and the Indianapolis Speedway who had a place on Manhasset Bay. Purdy-built commuters had become the gold standard by the late 1920s, when their clients also included Harold Vanderbilt and Marshall Field. (MS.)

Col. William Hester (1838–921), president of the *Brooklyn Daily Eagle*, appears to be too well attired in his white duck pants, yachting jacket, and cap to be fishing. However, that is exactly what he is doing aboard his 128-foot steam yacht *Willada*, under the watch of his captain and steward. (PC.)

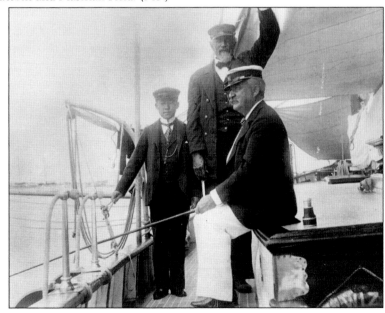

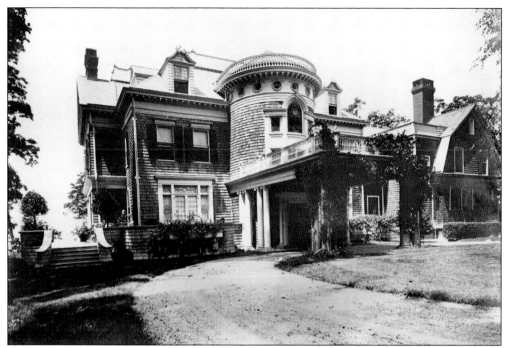

Willada Point, Hester's Glen Cove residence, is seen as it appeared when he acquired it from E.R. Ladew. Not liking its exuberant freestyle appearance, he would soon have Howard Major remove the tower and porte cochere in favor of a chaste Georgian Revival appearance. (PC.)

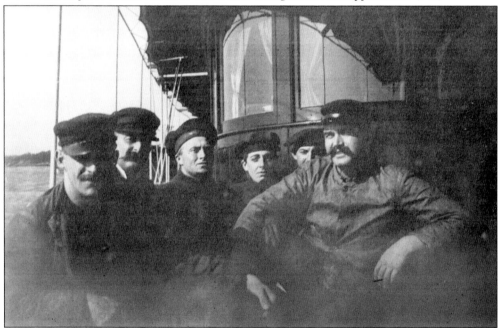

The crew of *Willada*, pictured on board around 1915, are a reminder of how labor intensive steam yachts were, requiring professional captains, officers, and engineers as well as deck hands, cooks, and stewards. The yacht, which had a triple-expansion steam engine, was built in 1899 by Pusey & Jones, the Wilmington shipyard. (PC.)

Pembroke, Capt. J.R. DeLamar's (1843–1918) palatial estate at Glen Cove, was remarkable even by the standards of the North Shore. The residence designed by C.P.H. Gilbert in the French Neoclassical style for the western mine owner and financier rose between 1916 and 1918 when DeLamar was already in his 70s. No vision was too large, however, for the great adventurer whose life story would have interested Horatio Alger. (PC.)

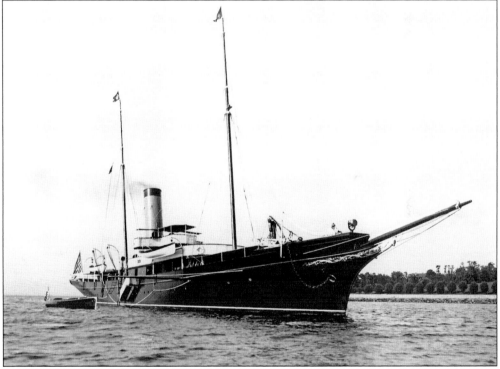

The DeLamar yacht *May* is seen here moored in front of Pembroke and in the previous picture at the extreme left. No stranger to the sea, DeLamar had been a merchant captain early in his career and owned *Sagitta*, one of the first commuting yachts powered by combustion engines. The beautiful *May*, which had been the flagship of the New York Yacht Club when owned by E.D. Morgan, was 240 feet overall. In naval service during World War I, she was wrecked in the West Indies in 1919. (GCL.)

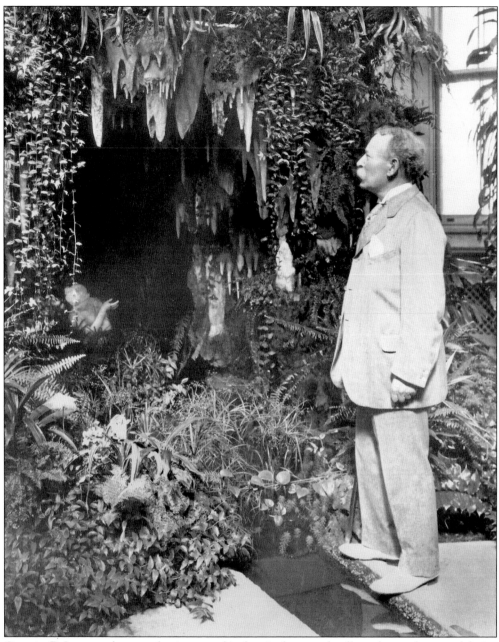

Captain DeLamar, who was also interested in horticulture and collected rare plants and fruits, peers into a grotto in his tropical house, which had a pool at its center. (GCL.)

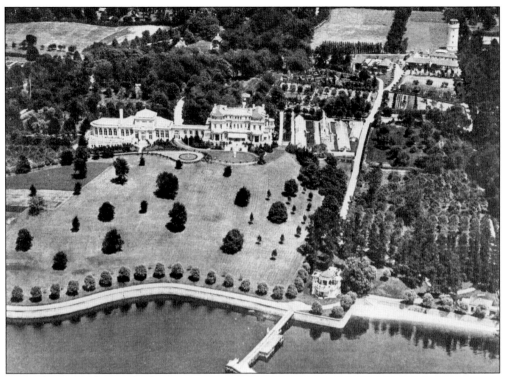

In the foreground is Pembroke's substantial dock. The plant or tropical house seen to the left was connected to the residence by an enclosed corridor. Among the estates other amenities were a motion picture theater, squash court, and shooting range. (TC.)

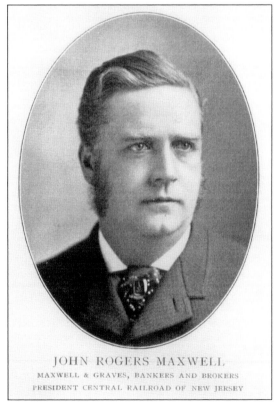

JOHN ROGERS MAXWELL
MAXWELL & GRAVES, BANKERS AND BROKERS
PRESIDENT CENTRAL RAILROAD OF NEW JERSEY

J. Rogers Maxwell Sr. (1846–1910), a Brooklyn businessman who summered at Glen Cove, and his sons were among the most active members of North Shore's yachting fraternity. A banker and director of many railroads, Maxwell was also president of the Atlas Portland Cement Company, which supplied cement used for the construction of the Panama Canal. (K.)

45

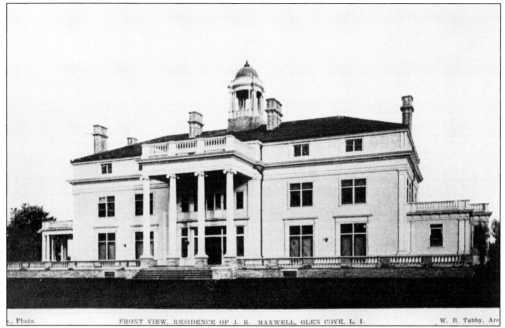

Maxwell's Glen Cove residence Maxwelton was designed by William B. Tubby, the Brooklyn architect who also worked for the Pratt family. Tubby was perhaps best known on Long Island for the Nassau County Court House and Jail (1899). The imposing Maxwelton, with its overscaled portico and massive cupola, had more the feeling of a public building than country house. It was later remodeled. (AB.)

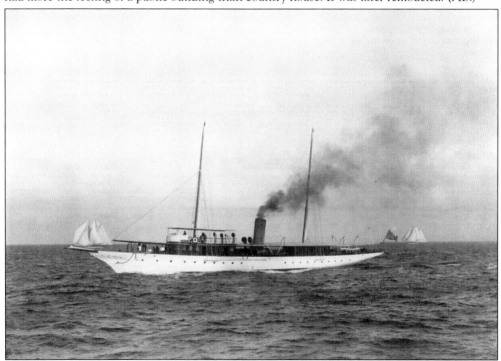

Maxwell owned at least 27 steam and sailing yachts between 1865 and his death in 1910. Seen above is his 170-foot steam yacht *Celt* following a schooner race about 1903. (HNE.)

An ardent Corinthian, or amateur, Maxwell sailed and sometimes designed his own boats, which included, at one time or another, the large sloops *Yankee*, *Humma* (seen here), and *Isolde*. He also owned the schooners *Emerald* and *Queen*, which were 112 feet and 126 feet overall, respectively. (MM.)

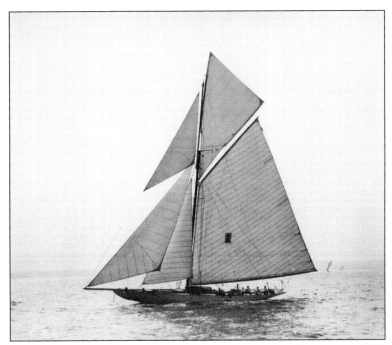

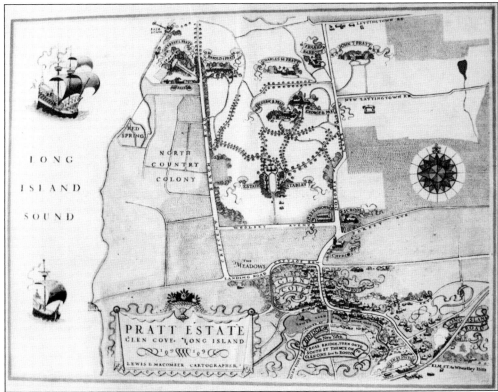

Dosoris Park, the Pratt family estate colony at Glen Cove, is seen in this 1919 map by Louis E. Macomber. The family compound established by kerosene magnate Charles Pratt in the 1890s was comprised of 21 residences and dozens of ancillary buildings by the 1930s. (PC.)

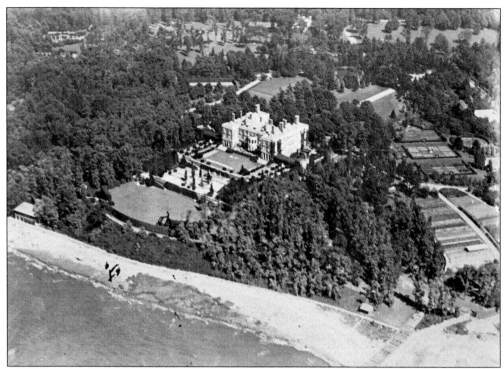

The Braes, Herbert L. Pratt's Jacobean residence at Glen Cove, designed by James Brite and built between 1912 and 1914, was one of the most imposing on the North Shore. Pratt (1871–1945), who served as president and later chairman of Standard Oil of New York, was an art collector and small boat sailor at Seawanhaka Corinthian Yacht Club. (PC.)

The Pratt bathhouse and dock pictured here is also seen at the upper left of the Macomber map (see page 47). (PC.)

Alegra, one of the first commuters on Long Island Sound, was built by Charles L. Seabury around 1890 for C.V.R. Cruger, who had a country house at Bayville. By 1893, she was owned by Charles M. Pratt. The 76-foot yacht's triple-expansion steam engine and could move her along at 18 miles per hour. (LC.)

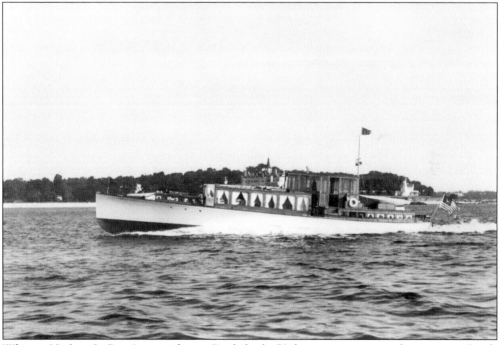

Whisper, Herbert L. Pratt's magnificent, Purdy-built, 72-foot commuter, seen here passing Sands Point with Beacon Towers in the center background, had been built in 1922 for Carl Fisher and was first known as the *Shadow F.* Pratt acquired *Whisper* in 1925, a few years after becoming head of Standard Oil. Purdy historian Alan E. Dinn notes her later name was surely a misnomer, as she was powered by two 12-cylinder Allison engines and must have been heard for miles. (MM.)

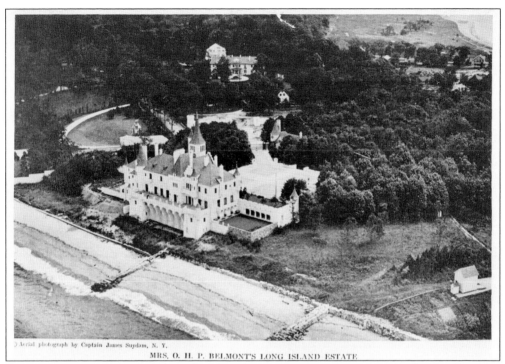

MRS. O. H. P. BELMONT'S LONG ISLAND ESTATE

Beacon Towers, seen behind the *Whisper*'s cabin in the previous image, was designed by R.H. Hunt for Alva Belmont (1917–1918). Loosely based on Seville's Alcazar and looking more like, as Richard Chafee suggests, a theater backdrop, the house must have given Alva Belmont the perfect vantage point to keep track of her sons Willie K. and Mike Vanderbilt as they passed by in their yachts. The estate would be acquired by William Randolph Hearst in 1927 for use by his wife. (AHT.)

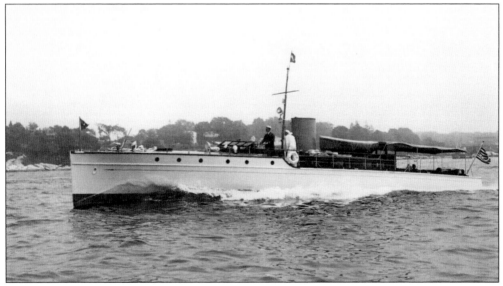

Tuna, corporate attorney John T. Pratt's 70-foot commuter, was designed by the well-known firm of Tams, Lemoine & Crane but built up in Boston by George Lawley & Son in 1917. Pratt died at the age of 53 of heart failure shortly after completing his morning commute on *Tuna* in 1927. (MM.)

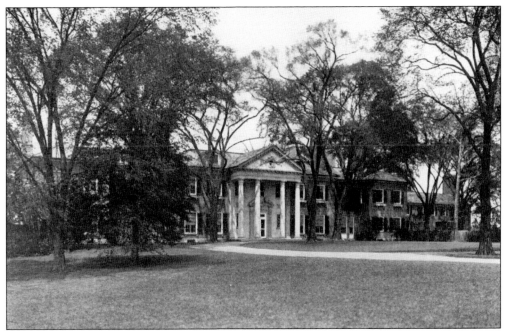

Manor House, John T. Pratt's Georgian residence designed by Charles A. Platt within his family's compound at Glen Cove, rose between 1909 and 1915 at a reported cost of nearly $300,000. It had an uninterrupted view of Long Island Sound from the second floor. In 1913, *Country Life in America* called it one of the 12 best country houses in America. It survives today as the Glen Cove Mansion Hotel and Conference Center. (MCAP.)

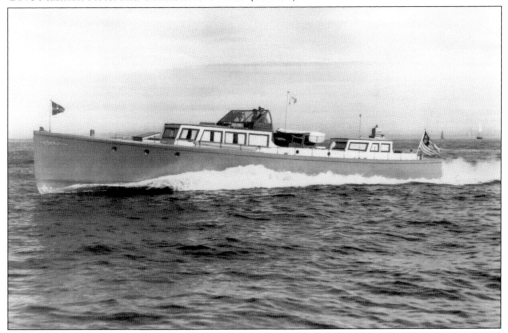

Sea Puss, a 65-foot commuter by Consolidated, was built in 1933 for John T. Pratt Jr. Without brightwork, she had the look of a patrol boat but moved right along powered by two V12 Wright Tornados. John's mother, Ruth Baker Pratt, was New York's first elected congresswoman. (MM.)

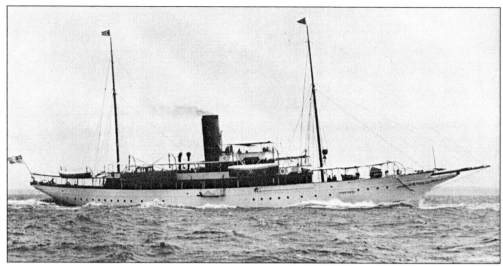

The estate of William L. Harkness (1858–1919), heir to a Standard Oil fortune, was on West Island at Glen Cove. A handsome residence by James Gamble Rogers, who would later design the Harkness Memorial at Yale, was short-lived. The Harknesses' 215-foot motor yacht *Cythera*, however, served in both world wars. When the ship was torpedoed off North Carolina in 1942, only two of *Cythera*'s crew, picked up by the U-boat that sank her, survived. (MM.)

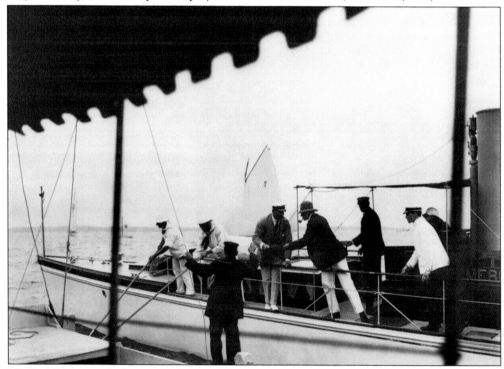

J.P. "Jack" Morgan Jr. (1887–1943), son of the great financier J. Pierpont Morgan, is pictured at the center (wearing a yachting cap with his hand on the rail) aboard *Mermaid*, the first of two Herreshoff steam-powered commuting yachts he owned. Jack, who succeeded his father as head of J.P. Morgan & Co. after Pierpont's death in 1913, served as commodore of the New York Yacht Club between 1919 and 1921. (MM.)

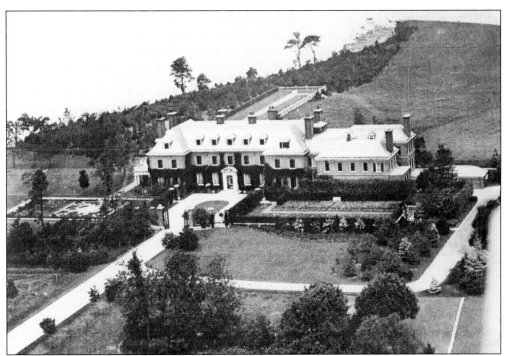

Matinecock Point, Morgan's 257-acre Glen Cove estate, stood close to the center of the North Shore's yachting world. The handsome 41-room, c. 1913 Georgian residence was designed by Christopher Grant La Farge, son of the stained-glass artist John La Farge. Morgan was shot twice here in an assassination attempt in 1915 but overcame his assailant and recovered. (TC.)

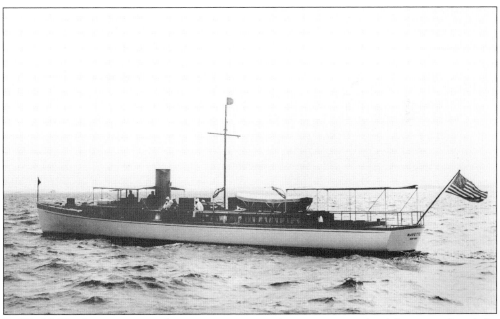

By World War I, steam-powered commuters were no longer in vogue, but Morgan preferred the hiss of steam to the roar of combustion engines. Built in 1917 by Herreshoff, his 114-foot *Navette* had a beam (width) of just 14 feet but got the financier to work on time. (MS.)

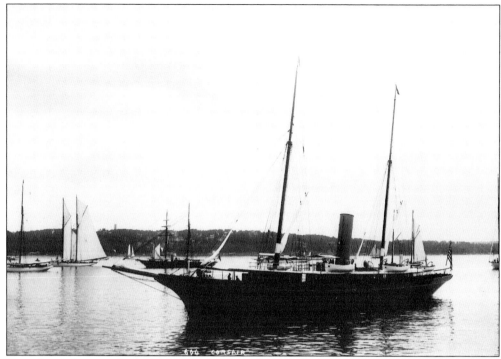

Considered the most beautiful of the famous series of Morgan yachts, *Corsair III* was designed by Irish naval architect J. Beavor-Webb and built in 1899. She is pictured here moored off Glen Cove. After J. Pierpont Morgan's death in 1913, the 303-foot steam yacht passed to his son. During World War I, she was part of the "suicide fleet," the small band of American yachts refitted for antisubmarine warfare that patrolled the French coast. (LC.)

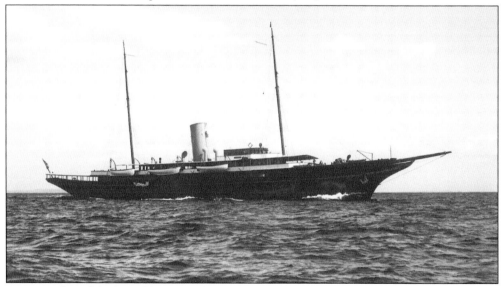

Corsair IV, last of the line of famous yachts owned by the Morgans, was 343.5 feet overall, designed by H.J. Gielow, and built by the Bath Iron Works in 1930. Jack Morgan would only have her for a decade, turning *Corsair* over to the Royal Navy for a dollar in 1940. After World War II, she was converted for use as a cruise ship and was lost and wrecked off Acapulco in 1949. (MS.)

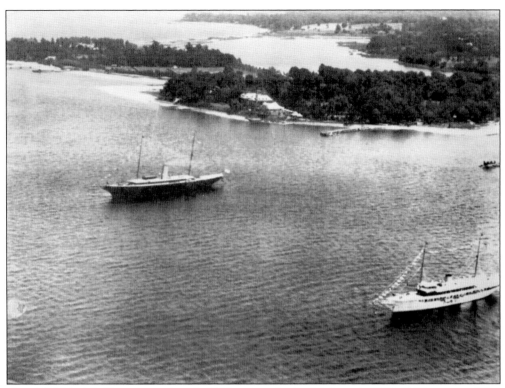

Corsair IV (black hull) is seen anchored off Salutations, Junius S. Morgan's (1892–1960) estate on West Island at Glen Cove, in this c. 1930 aerial view. The son of J.P. Morgan Jr., Junius was a banker and a commodore of the New York Yacht Club. An accomplished sailor with ability at naval architecture, he designed his own M-Boat, *Windward*, and owned the Herreshoff commuter *Shuttle*. (AC.)

Corsair IV is pictured where she was often moored off Glen Cove in this west-facing view. (PC.)

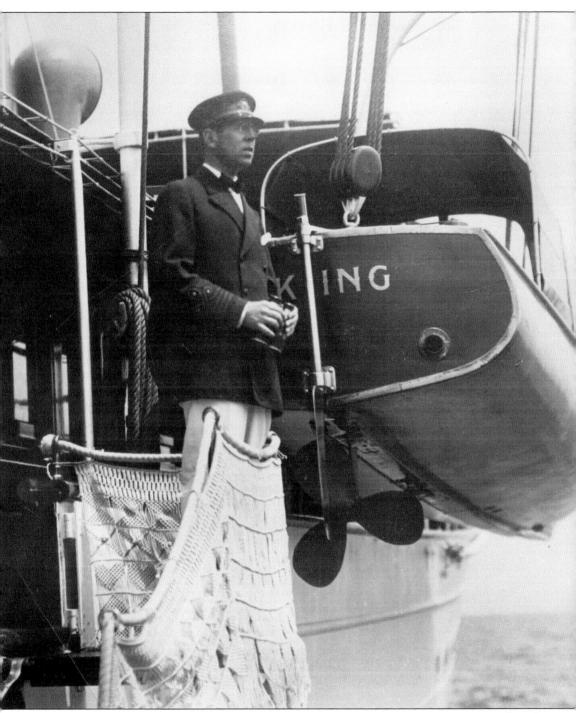

George F. Baker Jr. (1878–1937), who succeeded his father as chairman of the First National Bank (a precursor of Citibank), was an avid yachtsman who became commodore of the New York Yacht Club in 1914. On a round-the-world voyage on board his yacht *Viking* in 1937, Baker was stricken with appendicitis. A shipboard operation on the yacht's billiard table proved unsuccessful. Soon after arriving at Honolulu, Baker died of peritonitis. (PC.)

Baker's first *Viking* was a 180-foot, steel-hulled steam yacht designed by Theodore D. Wells, the well-known naval architect. The commodore's fleet also included a 72-foot racing sloop named *Ventura* and *Little Viking*, a commuter. (MM.)

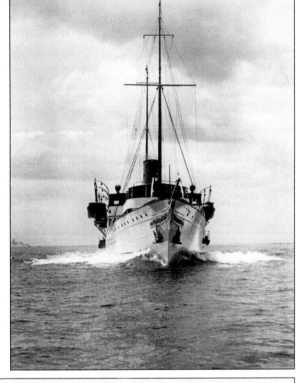

Built in 1909, *Viking I* was Baker's flagship when he served as commodore of the New York Yacht Club and was well known in local waters. Sold after the completion of his second *Viking*, she would pass through several hands, ending her days ignominiously and much altered as a Manhattan Circle Liner. (MM.)

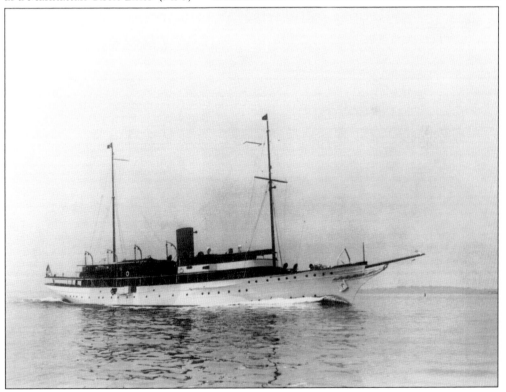

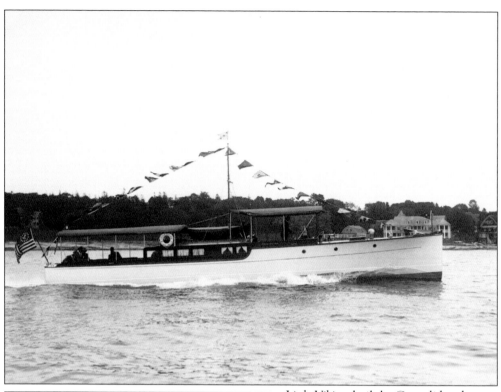

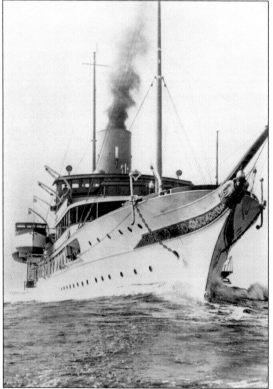

Little Viking, built by Consolidated on the Harlem River in 1927, was a 70-foot commuter capable of 27 miles per hour with its two Speedway engines. Baker would step on board in his dressing gown and change into business attire as the yacht sped toward the city. In 1929, Baker commissioned a second and considerably larger *Viking*. The 272-foot, turboelectric world traveler was also designed by Wells. (MSN.)

When moored off Vikings Cove on a summer evening, Commodore Baker was fond of projecting movies from *Viking*'s bridge on the main sail of *Ventura* anchored nearby. One night, the over-served wife of a neighbor stepping out on her balcony swore she had seen Indians chasing Tom Mix, the cowboy movie star, down Long Island Sound. Renamed USS *St. Augustine* during World War II, *Viking* was lost with 115 of her 145 hands after a collision on convoy duty off Cape May on January 6, 1944. (MM.)

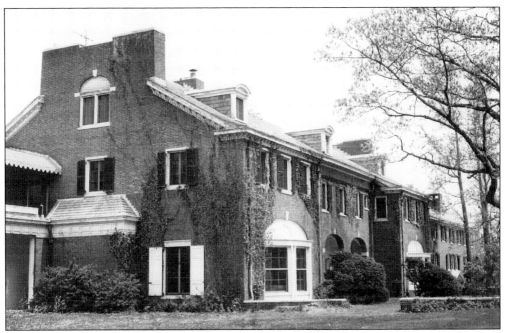

Vikings Cove, Baker's 1913 Georgian Revival waterfront residence in Lattingtown, was designed by Walker and Gillette. Walker, related by marriage, had been a year ahead of Baker at Harvard and would also design the First National Bank's new headquarters on Wall Street in the 1930s. Among the house's unusual features was a device on the roof that allowed the commodore to signal the crews of his yachts moored off Vikings Cove, should he require a launch. (PC.)

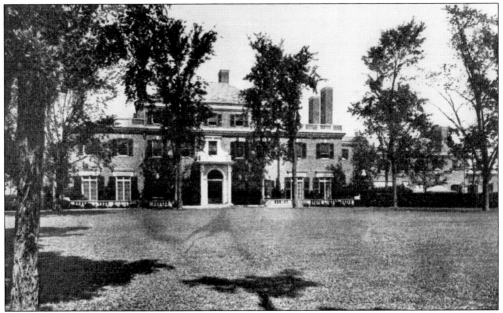

Harry P. Davison (1867–1922), the banker, senior partner at J.P. Morgan & Co., and Red Cross chairman during World War I, did everything well during his all-too-brief life. He would die of a brain tumor at 54 at Peacock Point, his Walker & Gillette residence in Lattingtown that had been completed in 1916. (AR.)

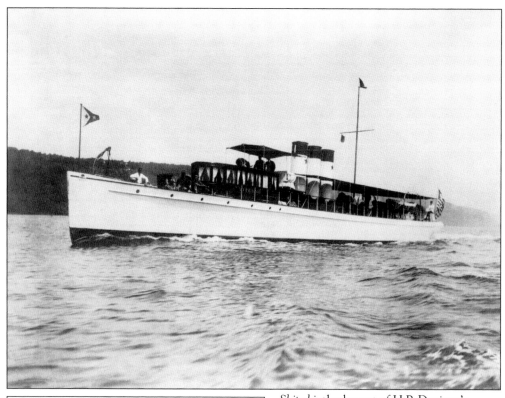

Skipaki, the largest of H.P. Davison's three yachts, was a 140-foot, twin-screw steamer that he used for commuting from 1916 to 1919. Designed and built by Charles L. Seabury in 1910, Davison was the second owner of the beautiful three-stack flyer. (MM.)

WILLIAM DAMERON GUTHRIE
SEWARD, GUTHRIE & STEELE, LAWYERS
WRITER ON LEGAL AND LITERARY TOPICS

California native William D. Guthrie (1859–1935), Rockefeller attorney, author, and educator, was drawn to the North Shore at the outset of the 20th century, joining both the New York and Seawanhaka Corinthian Yacht Clubs. (K.)

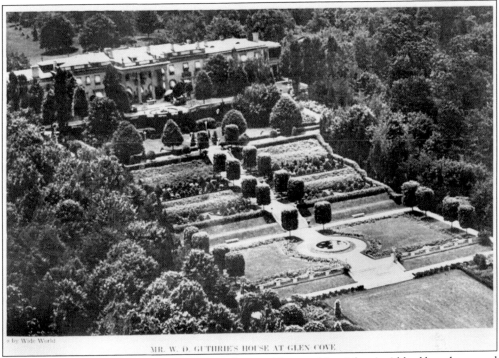

MR. W. D. GUTHRIE'S HOUSE AT GLEN COVE

To establish Meudon, his 300-acre estate, Guthrie and his neighbor John A. Aldred bought up and demolished the 60 buildings that comprised the village of Lattingtown. C.P.H. Gilbert was then brought in to design Guthrie's stunning Renaissance Revival residence from which descended the terraced gardens by Brinley & Holbrook and the Olmsted Brothers. (TC.)

This image looks toward Long Island Sound from Guthrie's residence in January 1912. (HN.)

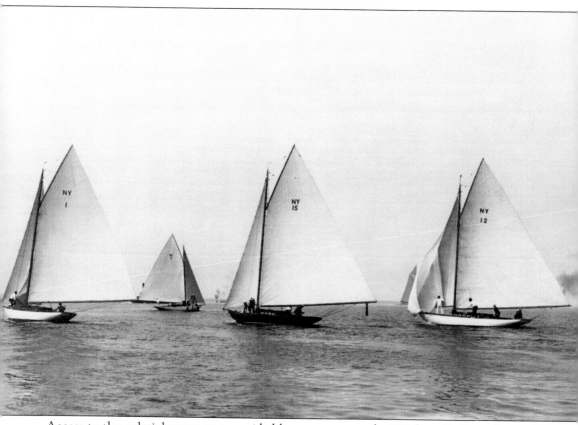

Access to the palatial estate was provided by a commuter, the 110-foot, Seabury-designed, steam-powered flyer also known as *Meudon*. Guthrie also owned a sailboat, *Maid of Meudon*, a New York Thirty that he campaigned in the competitive one-design sailing class seen above in 1905. (MM.)

Three

GREAT YACHTS
AND ESTATES
BAYVILLE TO NORTHPORT

Chapter three takes the reader even farther east on the Gold Coast, across the county line from Nassau into western Suffolk County as the survey continues of the great yachts, their owners, and waterfront estates. Bayville; Centre Island, where the Seawanhaka Corinthian Yacht Club is situated; Oyster Bay; and Cold Spring Harbor were home to some of the most legendary yachts during the era of elegance afloat, from the 1890s to World War II.

The phenomenon also continued around Lloyd Neck into Huntington Bay and its harbors, Huntington, Centerport, and Northport.

Long Island Illustrated, a 1903 Long Island Rail Road guide, described the Seawanhaka clubhouse as an "imposing structure, splendidly situated on Centre Island" where, on its "broad verandas during the yachting season, may be found a goodly assemblage of fair women and brave men."

Peter Winchester Rouss (1875–1932) owed his middle name to his father's hometown in Virginia. Charles "Broadway" Rouss had a dry goods store there before the Civil War, but the young Confederate soldier hopped a train to New York in 1866 and, in one of the great rags to riches stories of the era, made a fortune in the retail business building a large department store on Broadway. Peter, however, seemed more intent on spending the rewards. (PC.)

A substantial dock and breakwater protecting the anchorage from nor'easters are seen in this aerial of the Rouss estate at Bayville. (PC.)

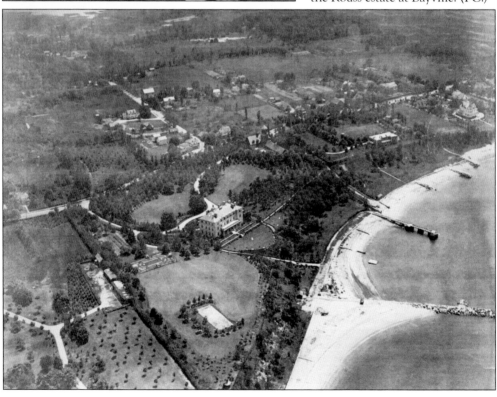

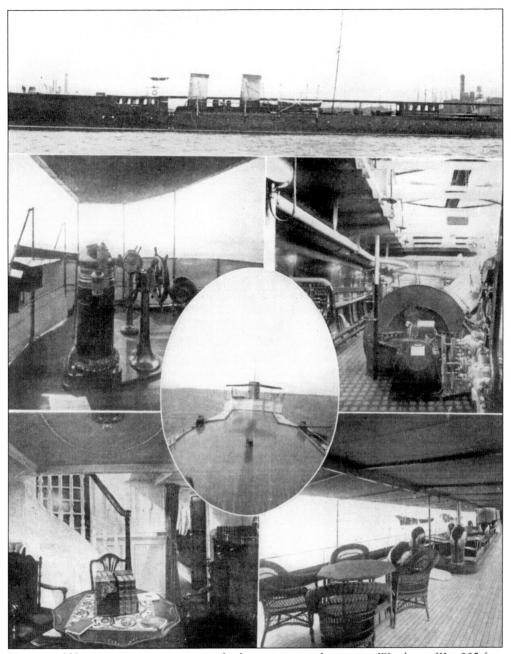

Rouss would have a new steam commuter built every two or three years. *Winchester III*, a 205-foot flyer built by Yarrow in England in 1912, was sold in 1915. Later owned by Solomon R. Guggenheim, she served in the Royal Canadian Navy as the HMCS *Grilse* during World War I. (PC.)

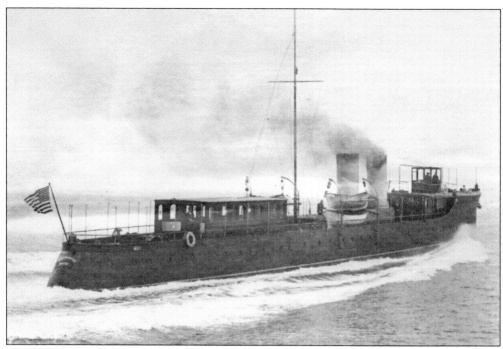

Winchester IV, larger and faster than her three predecessors, was a 225-foot destroyer look-alike designed by Cox & Stevens and built at the Bath Iron Works in Maine in 1915. (PC.)

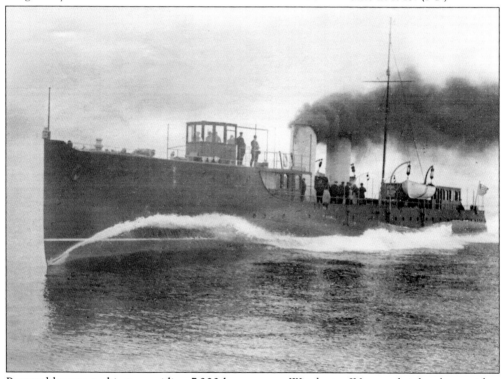

Powered by two turbines providing 7,000 horsepower, *Winchester IV* moved right along with a "bone in her teeth" (prominent white bow wave) at 31.7 knots. (PC.)

Mr. & Mrs. Rouss (right), daughters Margaret and Helen (left), and an unidentified man (far left) lean on the pilothouse while son Charles (far right) stands next to the rail with *Winchester IV* under way in this c. 1925 view. (PC.)

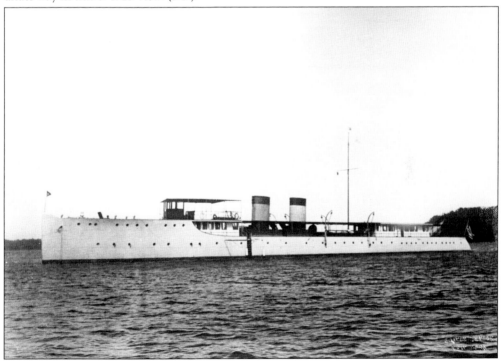

The extreme length (225 feet) of *Winchester IV* is evident here while she is pictured in the Seawanhaka anchorage with Coopers Bluff visible off her stern. Much of the space below decks, however, was taken up by the steam plant, coal bunkers, and crew quarters, leaving little space for the owner's accommodations. (MM.)

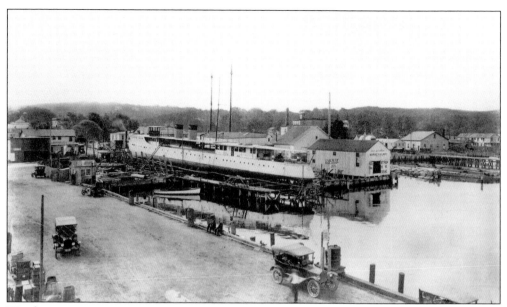

Winchester IV was quite a site when hauled at Port Jefferson, winter quarters for many North Shore yachts and home to a portion of *Winchester*'s crew. (PJVDA.)

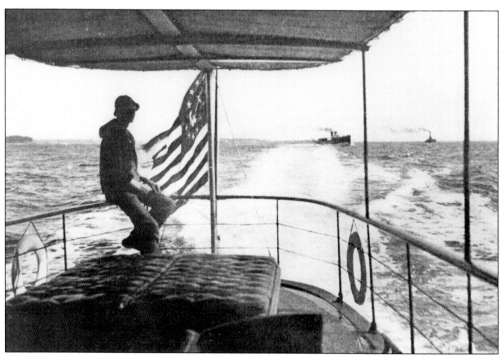

Winchester (III or IV) is seen here overtaking *Arrow* on their afternoon commute out from the city, about 1915. In 1910, *Arrow* (when owned by E.P. Whitney) and *Winchester II* transported the entire membership of the Seawanhaka Corinthian Yacht Club from Manhattan out to Oyster Bay for their annual dinner in September. (AC.)

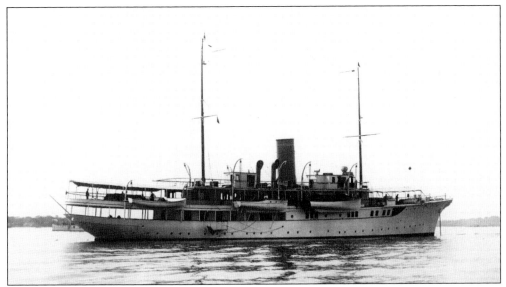

C.K.G. Billings's *Vanadis II*, at 240 feet overall, was the largest diesel-powered yacht that had been built at the time of her launching in 1924. Heir to a gaslight fortune and a founder of Union Carbide, Billings was an eccentric who had hosted a famous white-tie dinner on horseback in New York in 1903. Although he had built a country house, Farnsworth, at Matinecock in 1914, the California-bound industrialist did not remain long, selling *Vanadis* to Harrison Williams. (MM.)

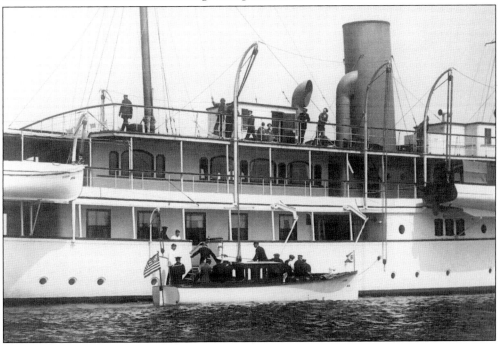

Vanadis's sedan launch, flying Billings's private signal (the flag with the "B" at the bow), is seen here as guests come aboard. Note the same launch pulled up on its davits in the full-length view of the yacht. Vanadis was designed by Cox & Stevens and built in Germany by Krupp. One of the few great yachts from this era to survive, Vanadis is today a floating hotel, the Malardrottningen in Stockholm, Sweden. (MM.)

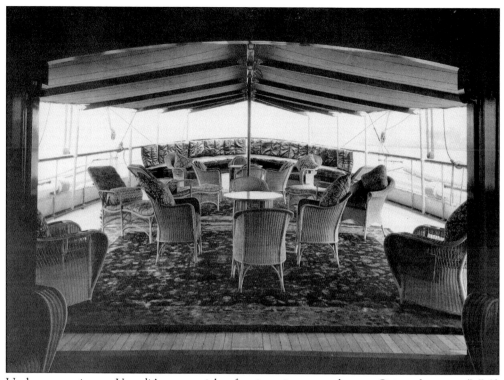

Under an awning on *Vanadis*'s stern, wicker furniture is arranged on an Oriental carpet. (MM.)

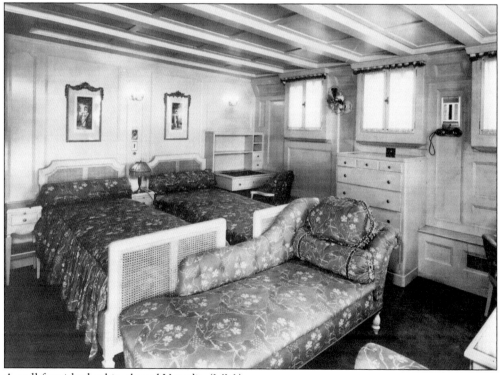

A well-furnished cabin aboard *Vanadis*. (MM.)

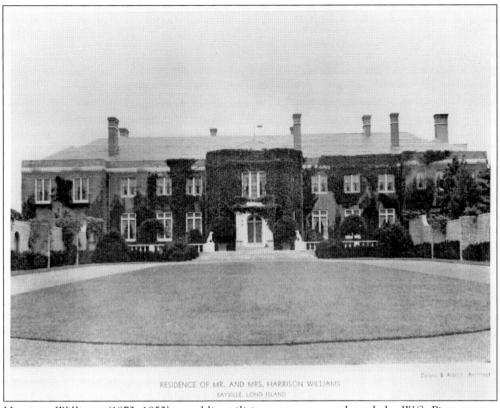

RESIDENCE OF MR. AND MRS. HARRISON WILLIAMS
BAYVILLE, LONG ISLAND

Harrison Williams (1873–1953), a public utilities magnate, purchased the W.S. Pierce estate in Bayville in the late 1920s, renaming the place Oak Point and calling on Delano & Aldrich to redesign the residence. He renamed *Vanadis* as *Warrior* and refit her for his own use and oceanographic cruises. (PC.)

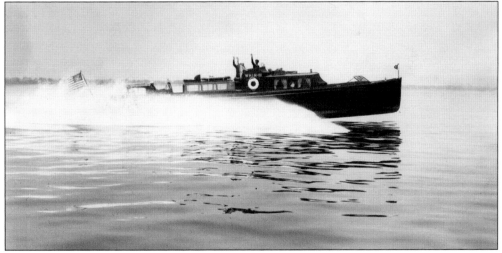

Powered by 650-horsepower V12 Wright Typhoon engines, *Whim III*, Williams's bodacious step-bottom commuter, could fly along at over 50 miles per hour. Designed by Tams and King and built by Consolidated on the Harlem River in 1928, she was also one of the most beautiful "business boats" stepping out on Long Island Sound every morning. (MS.)

The all-bright (varnished) *Whim III* was quite a sight. Note that the passengers are all in business attire. (MS.)

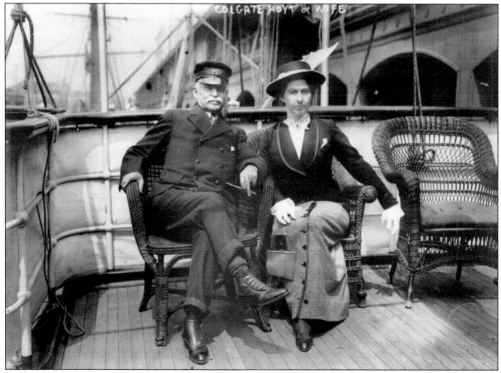

New York investment banker Colgate Hoyt (1849–1822) is pictured here around 1910 with his wife, Lida Williams Sherman, niece of Gen. William Tecumseh Sherman. (LC.)

Although his son later recalled that the Ohio native "barely knew the bow from the stern," when drawn to yachting that did not stop Colgate Hoyt from establishing his considerable estate near Seawanhaka. Eastover Farm ran across Centre Island from Cold Spring Harbor (above) to West Harbor (below). In this c. 1930 aerial view, Hoyt's country house is seen at center right along with the boathouse on West Harbor (lower right). (AC.)

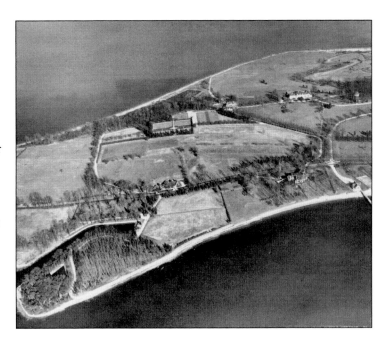

COLGATE HOYT ESTATE, CENTRE ISLAND, OYSTER BAY

Colgate Hoyt's country house, now believed to have been designed by C.P.H. Gilbert, was one of a number of residences built on Centre Island by Seawanhaka members. It was completed in 1892, the year the clubhouse opened. (AC.)

While Colgate Hoyt never was much of a sailor, he did own a few yachts. His nifty launch *Tide* is pictured here. (LC.)

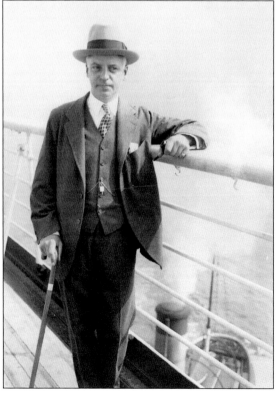

As was so often the case on the North Shore, it was Colgate Hoyt's son Sherman who would be called the best-known yachtsman in the world. (LC.)

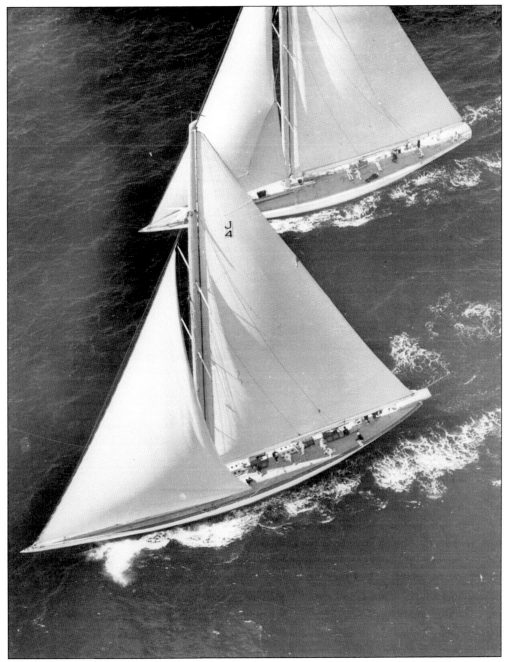

Sherman Hoyt's helmsmanship was credited with saving the America's Cup in 1934 when racing with Harold "Mike" Vanderbilt on the J-Boat *Rainbow*. *Rainbow* (foreground) is seen here during a trail race with *Weetamoe* to decide who would meet the English challenger *Endeavour*. Designed by Clinton Crane for a syndicate headed by the brother-in-laws Julius Morgan and George Nichols, *Weetamoe* was also a North Shore story. (AC.)

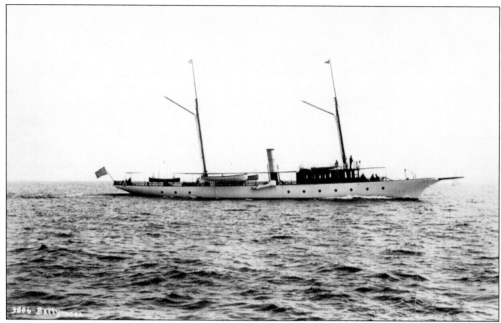

Samuel T. Shaw's *Bellemere*, originally known as *Ballymena*, is thought to have been the first steel yacht built by the Herreshoff Manufacturing Company. The 104-foot steamer had previously been owned by the Brown family of Rhode Island. (MS.)

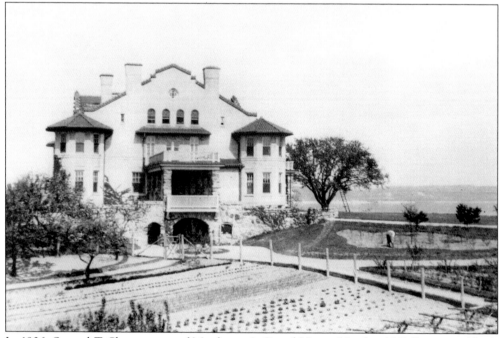

In 1906, Samuel T. Shaw, owner of Manhattan's Grand Union Hotel, sold *Bellemere* and built this Spanish Colonial country house, designed by Frederick R. Hirsh, at Plum Point, next to the Seawanhaka Corinthian Yacht Club. Shaw became an enthusiastic small-boat sailor. With water on both sides, even the house seemed at sea and was certainly the perfect vantage point to view yachting activities on both Cold Spring Harbor and Oyster Bay. (NYHS.)

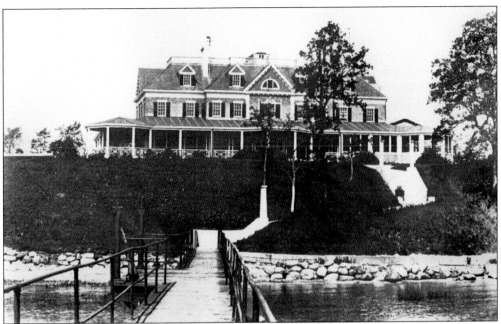

This c. 1910 image shows how Seawanhaka Corinthian Yacht Club at Centre Island in Oyster Bay appeared from its dock. (AC.)

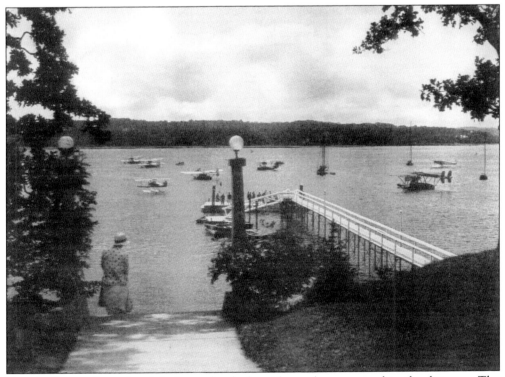

This 1931 view from the club shows the dock, with seaplanes moored in the distance. The Seawanhaka anchorage was a popular assembly point for the Long Island Aviation Country Club's air cruises to Montauk and New England during this era. (SPUR.)

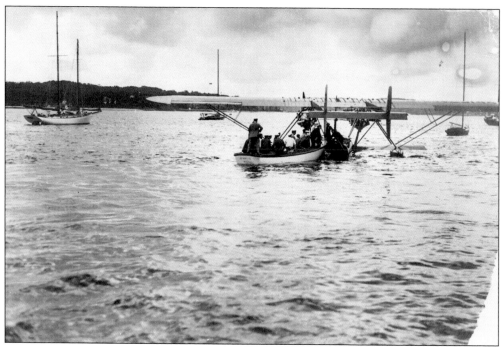

Boarding a seaplane from a boat was always tricky business. The aviators seen here were aboard the Seawanhaka launch *Resolute*. (PC.)

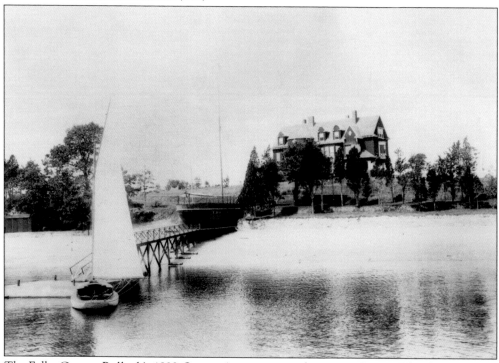

The Folly, George Bullock's 1892 Queen Anne country house on Centre Island just west of Seawanhaka, was short-lived. It burned before it was a decade old, but the real folly—the wonderful boathouse with the appearance of a ship's stern—survived for a century. (MCNY.)

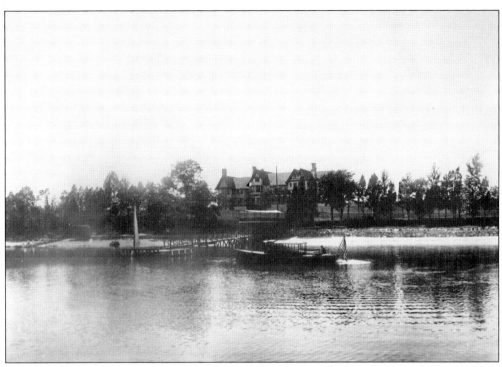

The Folly was rebuilt in 1899 to the designs of Renwick, Aspinwall & Owen. Here, the Seawanhaka launch approaches Bullock's dock and boathouse that survived the fire. (MCNY.)

A second story was added to the Bullock boathouse at some point in the 20th century. Legend holds that the stern was also used as the set for a film, which is entirely possible, as a subsequent owner of the estate was Albert E. Smith, cofounder of Vitagraph. The boathouse, which is no longer extant, is seen here in the early 1960s after being restored by Richard Orr of Mystic Seaport for then owner Walter S. Gubelmann. (AC.)

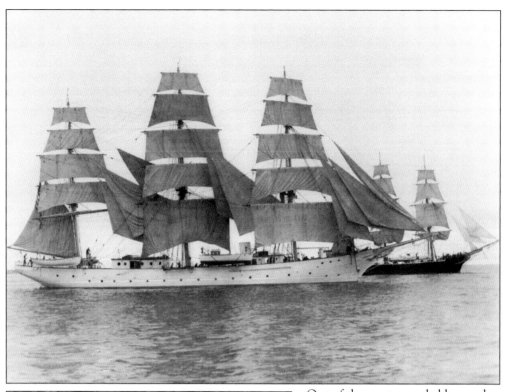

One of the most remarkable vessels sailing out of Oyster Bay before World War II was *Seven Seas*, a 168-foot, full-rigged ship that had been built in 1912 as a Swedish training vessel. She was owned by William S. Gubelmann, the inventor of adding machines, but it was his son Walter who was aboard for a series of match races to Bermuda and back in 1937, in which *Seven Seas* beat another square rigger, the *Joseph Conrad*. (MM.)

This image peers down from the rigging aboard the huge yacht *Seven Seas*. (MM.)

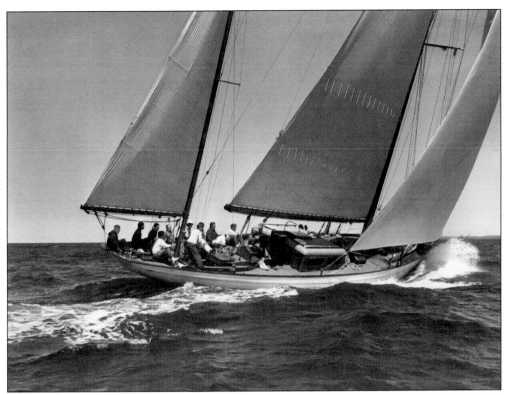

Walter S. Gubelmann would campaign *Windigo* after World War II. The 71-foot, ocean-racing yawl from Oyster Bay had been designed by Olin Stephens in the 1930s for Carl J. Schmidlapp II. (MS.)

Mistress, George Roosevelt's 61-foot, Sherman Hoyt–designed schooner, pictured here sailing toward the Cold Spring Harbor Light with Lloyd Neck in the background, never had an engine. The erudite Roosevelt, cousin of the presidents, was a sailing purist who saw no need for auxiliary power. A well-known ocean racer, *Mistress* would often be seen sailing out of Oyster Bay both before and after World War II. (MM.)

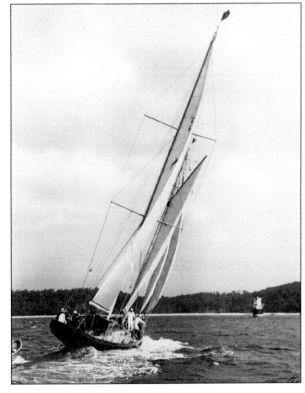

The foresail on *Mistress* was also traditional, being attached to the mast by hoops. As a result, Roosevelt's son Julian recalled having to grease the mast so that the sail could be raised or lowered easily. (MM.)

An accomplished blue-water sailor, Paul Hammond was a banker and a well-known North Shore yachtsman. He was also captain of the barkentine *Capitana* during the Harvard Columbus Expedition, which set sail from Oyster Bay in 1939 to study the voyages Columbus took. (Y.)

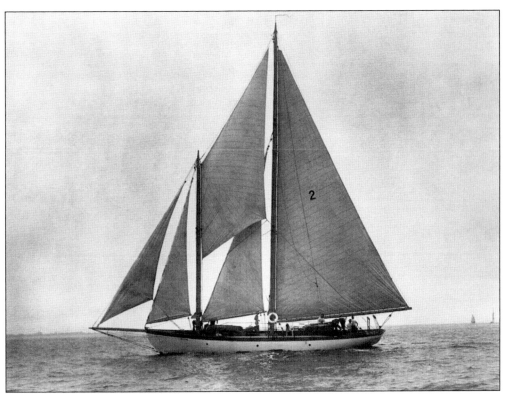

Nina, the famous ocean-racing schooner designed by Starling Burgess, victor in the 1928 race to Spain, was the first American yacht to win the Fastnet Race and was part of the Seawanhaka fleet when owned by Paul Hammond. She was lost at sea on a voyage from New Zealand to Australia in 2013. (MM.)

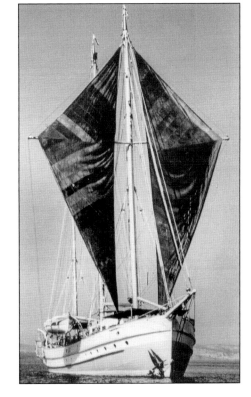

Oyster Bay was also the home port for *Rara Avis* (seen on the right), the last and most unusual of Hammond's seagoing vessels, built in Holland after World War II along the lines of a Thames sailing barge. (AC.)

Nelson Doubleday (1889–1949), son of the founder and chairman of Doubleday and Company, built his Harrie T. Lindeberg–designed Mill Neck residence, Barberrys, overlooking West Harbor in Oyster Bay about 1918. (FLO.)

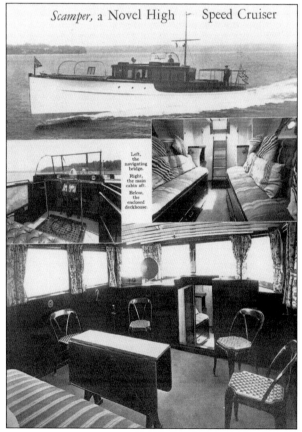

Scamper, Nelson Doubleday's 65-foot, W.J. McInnis–designed commuter, could move along smartly with two Sterling Coast Guard Motors that helped her attain the speed of 33.6 miles per hour during her trials. Built by Lawley in Boston, she was comfortable as well with a large forward cockpit and fine accommodations. (Y.)

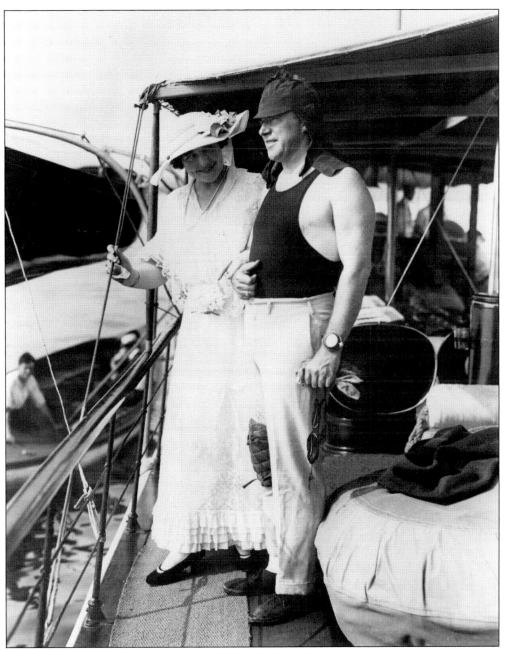

J. Stuart Blackton (1875–1941), the British born film director who cofounded Vitagraph, was a colorful character for whom the North Shore was the perfect stage. He is seen here with his actress wife, Paula, at the 1915 Gold Cup. The family fleet, which numbered 15 craft, included two steam yachts, a large sailboat, and the "Blackton babies," their race boats. J. Stuart's racers were all named *Baby Reliance* (I–V), while Paula had her own *Baby Demon* contenders. (MS.)

In this view, Blackton's steamer, *Arrow*, is seen under canvas in its winter berth in front of the boathouse at Harbourwood, his estate on Cold Spring Harbor. Designed by Hoppin & Koen to be both a boat and playhouse with a ballroom and bedrooms on the upper level, it is thought the Prince of Wales attended a late night party here with Broadway showgirls while attending the international polo matches at Meadowbrook in 1924. The last vestiges of the boathouse were demolished in 1983. (CH.)

The ballroom atop the boathouse, replete with the sort of trellised interior that Elsie de Wolfe was then popularizing, was also the scene of a Venetian party in 1915, long remembered by the guests. Blackton's large yachts illuminated with electric lanterns of Italian design, anchored a short distance off while small craft with costumed minstrels singing Italian love songs circled the revelers to complete the theatrical experience. (TR.)

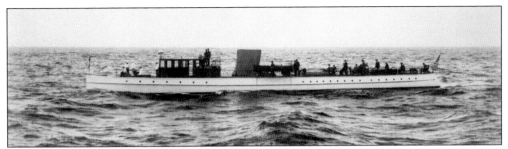

Arrow set the world record on water in 1902, when owned by C.R. Flint, steaming a mile at 45 miles per hour. The Mosher-designed, composite-built, steel-and-aluminum flyer was extremely light for her 132-foot length and even as a commuter with one boiler removed was capable of 30 knots. (AC.)

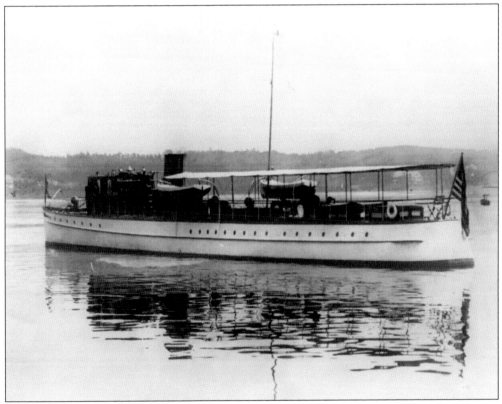

In this 1905 image, the 130-foot *Arrow* is seen anchored in Oyster Bay with Cove Neck in the background, where subsequent owner E.F. Whitney had a country house. The famous yacht was almost lost in 1908 when a steam pipe exploded, scalding 2 of her crew of 14 and starting a fire. *Arrow* was about to pick up Whitney at Twenty-third Street in the city at the time. By 1915, he had sold her to Blackton. (LC.)

Looking south out of the boat well at the Harbourwood boathouse in 1915, this remarkable view captures both *Arrow* to the left and Blackton's 185-foot steam yacht *Sagamore* about to dock on the right as guests wait. (TR.)

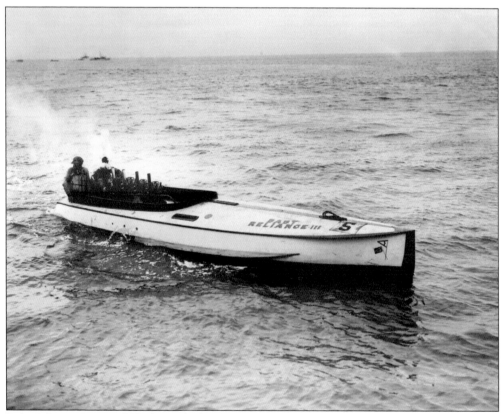

Baby Reliance III, one of Blackton's hydroplanes, competed in the 1912 Harmsworth Trophy races on Huntington Bay. (MS.)

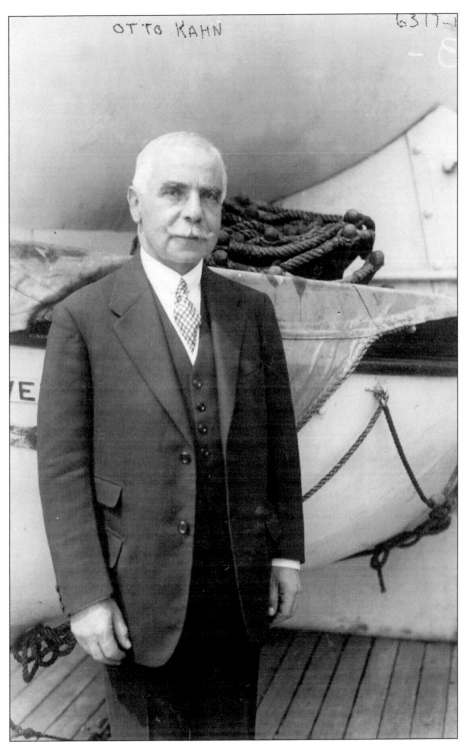

Otto Kahn (1867–1934), the German-born investment banker, is pictured here as he returns from a trip to Europe in 1925. Arriving in America in 1893, he went to work for Kuhn, Loeb & Co., where his father-in-law was a partner and began his legendary career reorganizing railroads. (AC.)

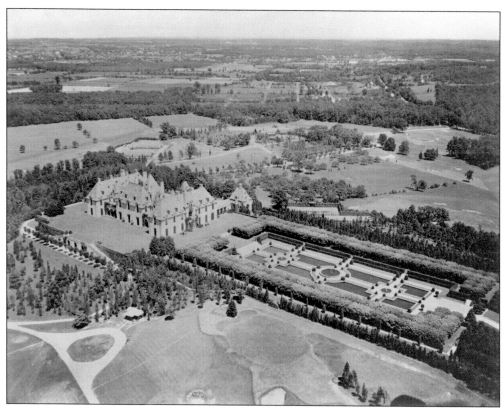

Looking down Cold Spring Harbor to the south, the roofline of Oheka, Kahn's palatial country house, is still very evident almost a century after its construction. Designed by Delano & Aldrich and comprised of approximately 72 rooms, Kahn's great chateau was in a category by itself and has been called the second-largest private residence in America behind George Vanderbilt's Biltmore in Asheville, North Carolina. (NCM.)

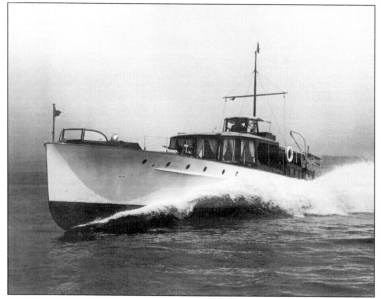

Kahn's preference for German technology was fully demonstrated by *Oheka II*, his 1927 commuter built by Lurssen of Germany and powered by three Maybach zeppelin engines. The 73-footer must have been a real head-turner as she roared in from Long Island Sound to her anchorage in Cold Spring Harbor. (MM.)

Walter Jennings's (1858–1933) estate, Burrwood, on the east side of Cold Spring Harbor, with its magnificent Carrere & Hastings–designed residence (1898–1900) was one of the showplaces of the North Shore. With a pier and extensive waterfront, it would have been an ideal place to moor a great yacht, but Jennings, a director of Standard Oil of New Jersey, was an angler content with his 45-foot cruiser *Jock Scott*, named for a favorite salmon fly. (SPLIA.)

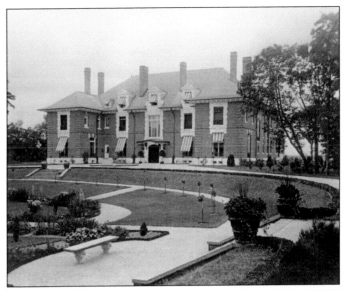

It would be another generation before a legendary yacht appeared in these waters. In 1938, Jennings's son-in-law, Henry C. Taylor's, Sparkman & Stephens–designed yawl, *Baruna*, the pride of Cold Spring Harbor, won the Bermuda Race and began compiling its remarkable ocean-racing record. Henry and Jeanette Jennings Taylor's residence, Cherridore, overlooked the water just south of Burrwood. *Baruna* is seen above finishing the 1938 Bermuda Race. (AC.)

William J. Matheson, who made a fortune importing synthetic dyes from Germany, acquired the 315-acre Fort Hill estate on Lloyd Neck in 1900 and began remodeling an existing shingle-style house that had been designed by McKim, Mead & Bigelow. The result, a massive Tudor Revival country house designed by Boring & Tilton, literally encased the earlier building and resembled a Scottish keep above the channel leading to Oyster Bay and Cold Spring Harbor. (PC.)

Motorists approaching Fort Hill drove through the gatehouse and along the west shore of Lloyd Neck past Matheson's boathouse before the road ascended the hill to his majestic residence. (PC.)

William Matheson's handsome boathouse, seen above with his private signal (flag) flying from the pole, has been attributed to Robert W. Gibson, the architect of Seawanhaka. Gibson's own house was across the harbor on the Cove Neck shore, and his initials appear on this rendering. (SPLIA.)

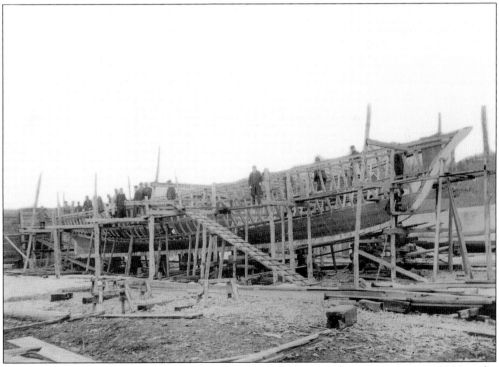

Laverock, Matheson's 103-foot steam yacht, is pictured above under construction in 1899 at the Port Jefferson yard of J.M. Bayles & Son. (PJ.)

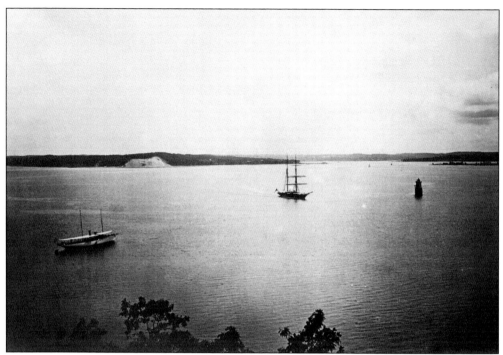

In this view looking down from Fort Hill House, *Laverock* is moored to the left while Arthur Curtis James's first *Aloha* is under way and about to round the Cold Spring Harbor Lighthouse. In the background, Coopers Bluff at the end of Cove Neck to the left and Plum Point to the far right frame the entrance to Oyster Bay. (PC.)

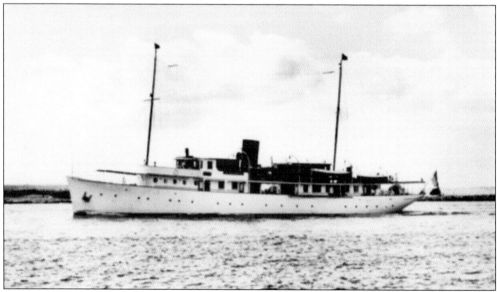

Seaforth, William Matheson's last sizable yacht, was a 148-foot, diesel-powered, steel-hulled motor yacht. Built in 1926, it resembled Vincent Astor's earlier *Normahal* and had been designed by the same firm, Cox & Stevens. The industrialist would travel far and wide on his oceangoing yacht, passing away on board of a heart attack while returning from a cruise to the Bahamas in 1930. (PC.)

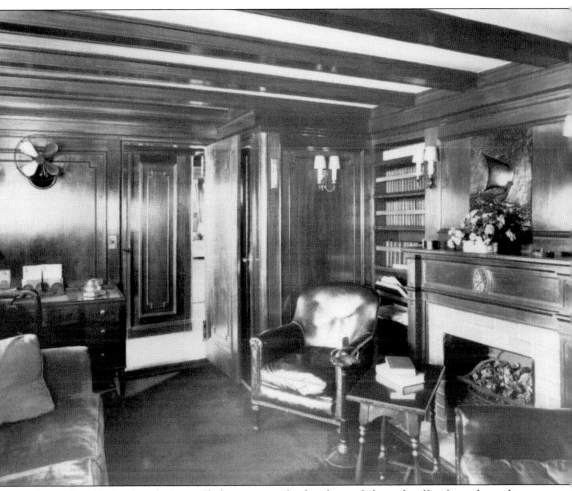

A comfortable leather chair is pulled up next to the fireplace, while a pile of books and standing ashtray await Matheson and his guests in the *Seaforth*'s den. (PC.)

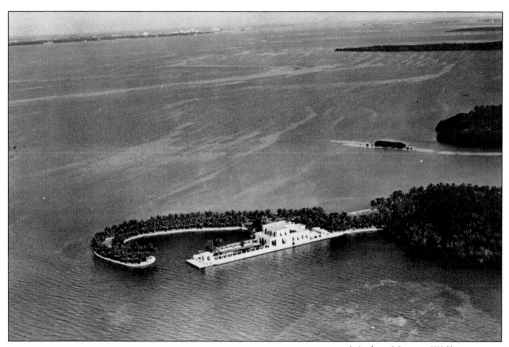

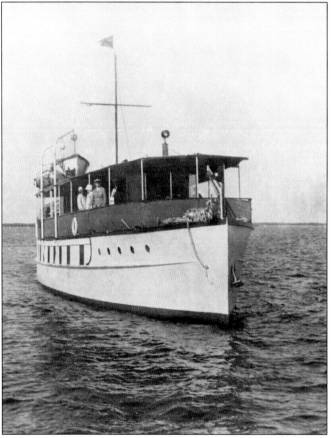

Mashta House, William Matheson's spectacular Moorish-style residence at Key Biscayne, Florida, could only be reached by boat when it was built in 1909. Hence, a portion of the industrialist fleet was always in Florida waters. (PC.)

Matheson was also a patron of Mathis Yacht Building Company of Camden, New Jersey, where John Trumpy was designing elegant houseboats. *Calabash* (at left) was a 70-footer built in 1912 by Mathis and primarily used by Matheson in Florida waters. (PC.)

It is unlikely that Marshall
Field III (1893–1956),
the investment banker,
publisher, and heir to the
Chicago department store
fortune, pictured here
with his first wife, Evelyn
Marshall, would have
considered establishing
an estate as far east as
Lloyd Neck without the
advantage of commuting
by water. (PC.)

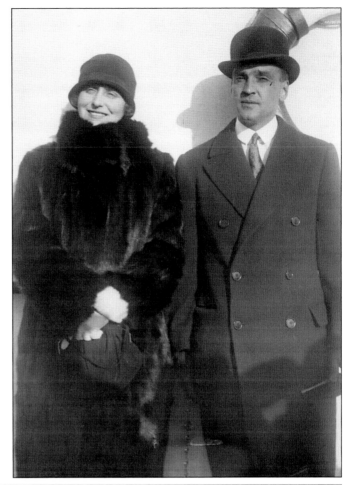

Baronial in scale, Caumsett,
Field's Lloyd Neck estate,
was comprised of several
thousand acres. Its creation
in the mid-1920s was to
involve the best talent
available, including John
Russell Pope, architect
of the National Gallery
and Jefferson Memorial
in Washington, and the
Olmsted Brothers as
landscape architects. (PC.)

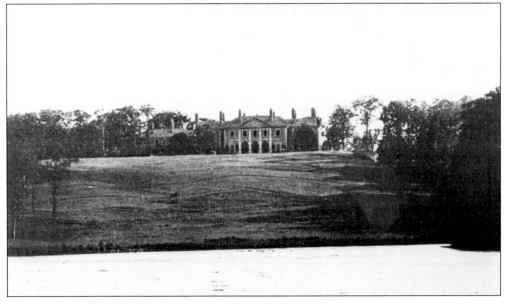

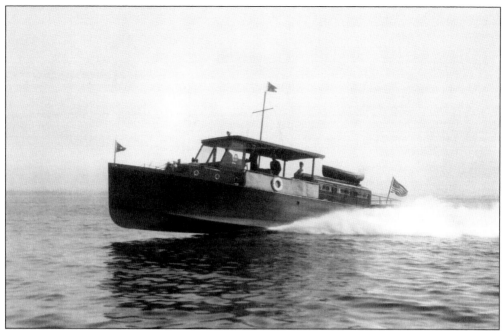

Designed by Gold Cup racer Gar Wood and first powered by a pair of 450-horsepower Libertys, the high-powered combustion engine developed for World War I aircraft, Marshall Field's 50-foot commuter *Corisande* was one of the fastest on Long Island Sound in the 1920s. She would consume 87 gallons of gas on the run into the city. (MM.)

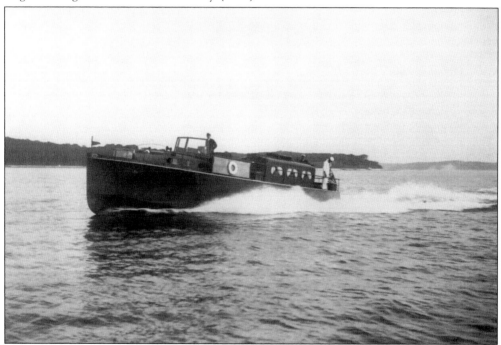

Corisande II, Fields's second commuter, was built by the well-regarded Purdy Boat Company of Port Washington in 1932 and was 15 feet longer than the first. She is pictured here with the Lloyd Neck shoreline in the background and Cooper's Bluff at Cove Neck visible at the far right. (MM.)

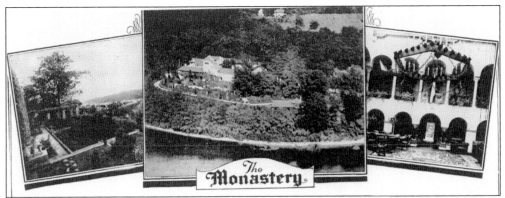

Juliana Armour Ferguson, an early yachtswoman and mother of seven, could look down on Huntington Harbor from the Monastery, her 50-room Italian Renaissance residence that was designed by the Boston architect Allen W. Jackson and begun in 1908. Ferguson was the daughter of Herman D. Armour (cofounder of the meatpacking firm) and a member of the Huntington Yacht Club. Ferguson's Castle, as it was known locally, is no longer extant. (AC.)

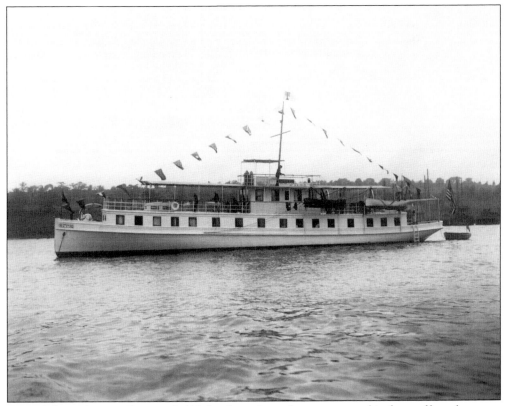

Osiris, Juliana Armour Ferguson's 110-foot houseboat that was moored in front of her place, was built in Port Jefferson by J.M. Bayles & Sons and had the generous beam of 20 feet, an ideal width for entertaining afloat. Osiris was the Egyptian god of the afterlife, and the vessel preceded Ferguson in that direction, burning the year before she died in 1921. (MM.)

August Hecksher (1848–1914), a German émigré who made his fortune in mining, was a man of wide-ranging interests and a great benefactor. His love of yachting is less well known, but it was a Hecksher syndicate that developed *Dixie IV*, the Harmsworth Cup racer that set a world speed record on Huntington Bay. He would own many yachts, including the 202-foot steam yacht *Anahama*, and serve as commodore of both the Seawanhaka and Huntington Yacht Clubs. (AC.)

Wincoma, August Hecksher's Italianate residence on Huntington Harbor, is seen here with its water views in a c. 1940 real estate advertisement. While August was a powerboat enthusiast, as was so often the case on the North Shore, his son G. Maurice Hecksher became an accomplished sailor and owned the 72-foot racing sloop *Aschula*. (PC.)

Cabrilla, August Hecksher's stylish 115-foot express cruiser used for commuting, was the largest yacht by Atkin-Wheeler of Huntington. Billy Atkin (1906–1962), one of the country's foremost creators of small yachts, designed the vessel and its power plant, *Cabrilla*'s pair of 750-horsepower V8 engines, which were also built by Atkin-Wheeler. (TP.)

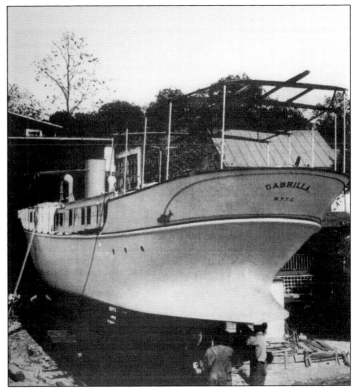

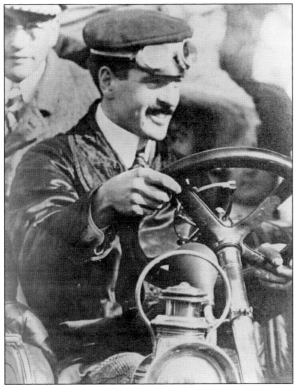

On receiving a summons in 1900 for breaking the speed limit in Newport, William K. Vanderbilt II (1878–1944), known to friends as "Willie" or "Willie K.," was quoted as saying it was "nothing to pay fines for such sport." The next year, Vanderbilt and his wife, Virginia, moved to Long Island, which would be the great stage for his automotive accomplishments, including the Vanderbilt Cup and Long Island Motor Parkway. The young sportsman, however, who would twice set the world speed record on land, was just as interested on going fast on water. (SCVM.)

Vanderbilt's first wife, Virginia Fair Vanderbilt, was a Californian, the daughter of an Irish immigrant who had made a fortune in mining. The vivacious Virginia loved outdoor sports, and the *New York Times* in 1898 called her "an excellent wip" and "a good wheelwoman" who "swims, fences, and golfs with equal skill and charm." Seemingly the perfect match for Willie K., she accompanied him on his yachting adventures and he would name his big racing sloop the *Virginia*. (SCVM.)

Vanderbilt actively campaigned the *Virginia*, his 70-foot racing sloop built by Herreshoff and named for his wife. In 1905, he was elected commodore of Seawanhaka Corinthian Yacht Club. Clinton Crane, the naval architect who was Willie K.'s mate on the *Virginia*, would recall years later that Vanderbilt was shy but had a very engaging personality. (SCVM.)

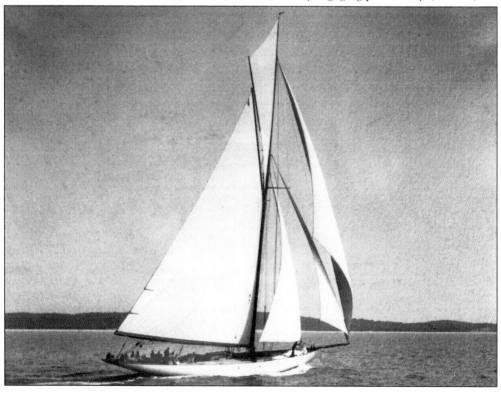

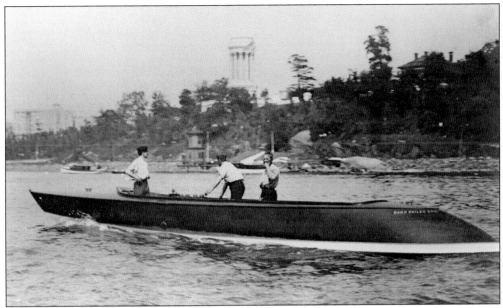

Hard Boiled Egg, Willie K.'s motorboat, or "auto boat," as they were then called, owed its name to the hope that it could not be beat. Seen here on the Hudson about 1904, Vanderbilt also raced her on Long Island Sound. In a surviving photograph of a 19-mile race she won off New Rochelle, the always-game Virginia Vanderbilt is seen at the wheel. (SCVM.)

Deepdale, a farmhouse at Lake Success that was handsomely remodeled by the distinguished architectural firm of Carrere & Hastings in 1903, would be the Vanderbilt's first residence on Long Island. Willie K. and Virginia would reside here until they separated in 1909. (SCVM.)

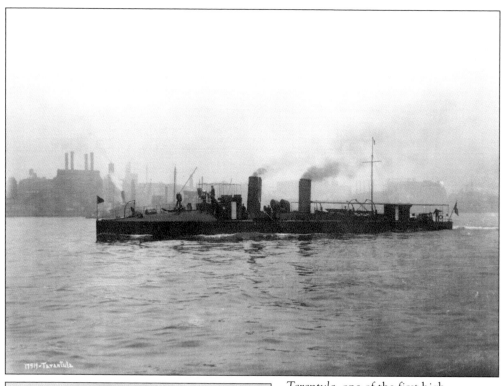

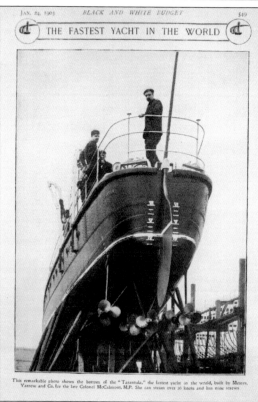

THE FASTEST YACHT IN THE WORLD

This remarkable photo shows the bottom of the "Tarantula," the fastest yacht in the world, built by Messrs. Yarrow and Co. for the late Colonel McCalmont, M.P. She can steam over 20 knots and has nine screws

Tarantula, one of the first high-speed turbine yachts, was designed by Cox & King and built in 1902 by Yarrow, the English yard known for torpedo boats. Acquired by William Vanderbilt in 1904, the flyer was towed to Bermuda by a British steamer and made the rest of the way under her own power as the media followed every sighting. Vanderbilt used her to commute and in the cup races against Howard Gould's *Niagara IV*. (HNE.)

With nine propellers on three shafts powered by as many Parsons steam turbines, *Tarantula*'s propulsion was impressive, but so was her wake. Clinton Crane, who oversaw the installation of new boilers for Vanderbilt to increase the flyer's speed, recalled that running down the East River, *Tarantula*'s wake produced waves that "broke like surf on the shore." Damage claims poured in from those who had property or vessels moored along the banks, and Vanderbilt lost at least one court case. (AC.)

Eagle's Nest, Vanderbilt's Centerport estate, was on the water offering all the advantages a yachtsman could desire. Built in several phases with Warren and Wetmore as architects for the residence, Eagle's Nest would evolve into a sportsman's paradise with a golf course, boathouse, seaplane hanger, hall for marine specimens, and an ideal anchorage. (SCVM.)

In contrast with his residence, Vanderbilt's charming boathouse at Eagle's Nest was in the English half-timbered style with a jerkin head roof and commanding view of Northport Harbor. (SCVM.)

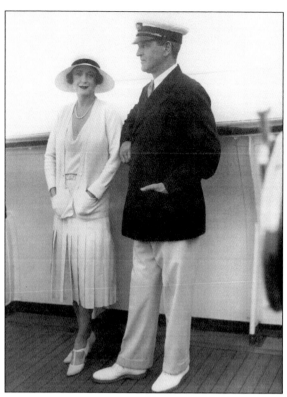

Rosamond Lancaster Warburton, who would become Willie K.'s second wife in 1927, had previously been married to a Wanamaker heir. She would accompany Vanderbilt on his great voyages. (MM.)

Vanderbilt purchased *Ara* in 1922. She had been built in England five years earlier, and he would make good use of the 213-foot motor yacht for his scientific expeditions in the 1920s and early 1930s collecting marine specimens and anthropological artifacts around the globe. (MM.)

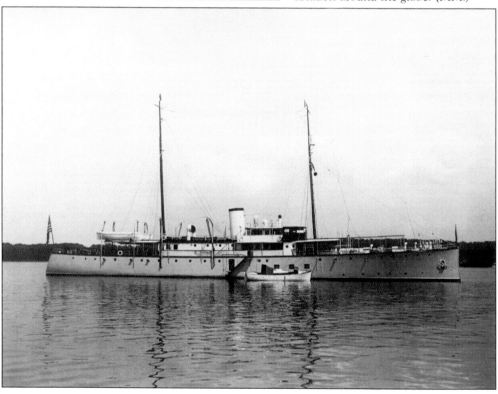

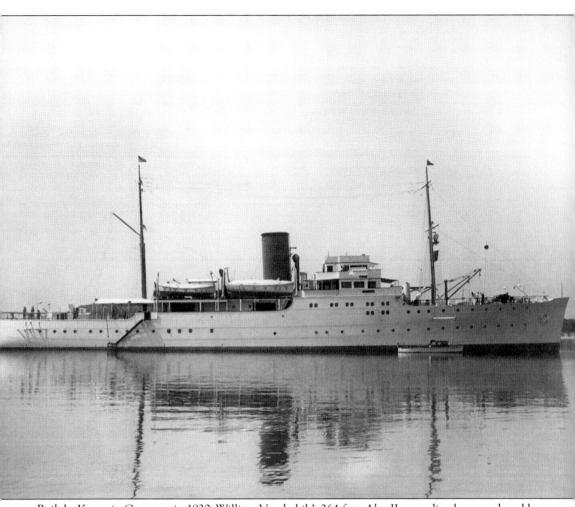

Built by Krupp in Germany in 1930, William Vanderbilt's 264-foot *Alva II* was a diesel-powered world voyager; the perfect vessel for her owner's frequent cruises to far off places. In 1941, however, with war imminent, Vanderbilt turned *Alva* over to the US Navy. His sister Consuelo, the American duchess, felt that in his heart he knew he would never see his prized yacht again. (MM.)

This deck view was photographed from aboard Alva. (TC.)

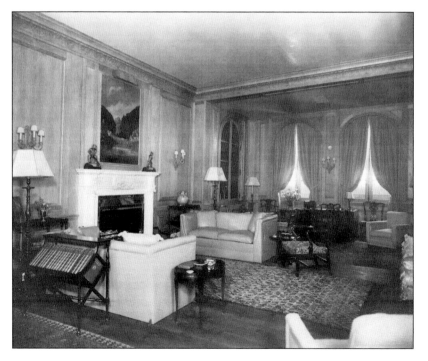

Would anyone have known they were afloat when sitting in the "living room" aboard Alva II? (MM.)

This elegantly appointed head (bathroom) was photographed aboard *Alva II*. (MM.)

Rosamond Vanderbilt's stateroom featured mahogany furniture, ivory walls, and blue taffeta curtains. (TC.)

Alva II is seen here docked at Fisher Island, Florida, Vanderbilt's winter quarters. Known as Alva Base, it had just about all of the amenities of Eagle's Nest and a residence designed by the popular Palm Beach architect Maurice Fatio. (MM.)

The *Alva II* was renamed the USS *Plymouth* by the Navy in World War II. She was torpedoed while on convoy duty off North Carolina and sank in two minutes. More than half of her 183-man crew was lost. Rescue efforts were hampered by heavy seas and sharks. (SCVM.)

Four

THE VISITORS
ITINERANT YACHTS AND YACHTSMEN

Not every yachtsman had a waterfront estate. Chapter four surveys some of the famous figures whose country houses were near but not on the water or frequented the North Shore during the pastime's golden age but lived elsewhere or stayed aboard their well-appointed vessels. E.C. Benedict, Harold S. "Mike" Vanderbilt, and Arthur Curtiss James, for example, all served as commodore of Seawanhaka and spent a great deal of time aboard their yachts off Oyster Bay but never had places ashore. Others who lived near but not on the shore included Ralph Pulitzer, Ogden L. Mills, and the E.F. Huttons. There were even a few equestrians who were yachtsmen, such as E.D. Morgan, a master of the Meadowbrook Hunt who owned the steam yacht *May* before J.R. DeLamar. The Old Westbury sportsmen H.B. Duryea and H.P. Whitney, more associated with horseracing and polo, owned together a 70-foot Herreshoff sloop. Turfman Whitney also owned—or perhaps a better word would be *sponsored*—several other sailing and power yachts. Finally, a few well-known yachtsmen who owned property on the North Shore but whose participation in the pastime occurred elsewhere, have been omitted. C. Oliver Iselin, for example, a fierce competitor who managed three America's Cup defenders, did not build his Brookville country house until he was about 60 and was well past his yachting accomplishments.

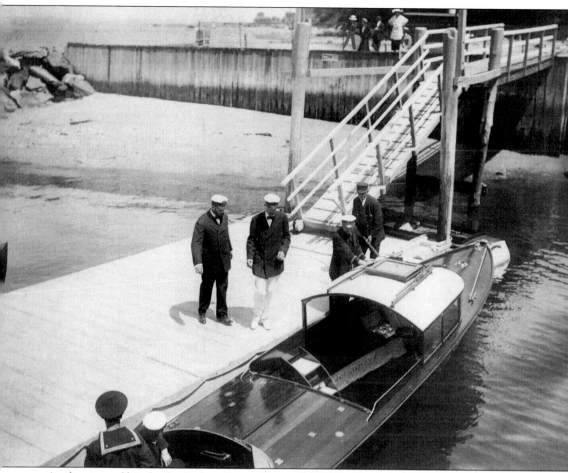

At the time of his death, Arthur Curtiss James (1867–1941) was said to have been the largest individual holder of railroad shares in the country. His family's considerable fortune, however, had been formed more than a century before when his grandfather founded the Phelps-Dodge Corporation. James is seen here in the dark pants about to board his elegant launch at the New York Yacht Club's Station 10 landing at Glen Cove. (MM.)

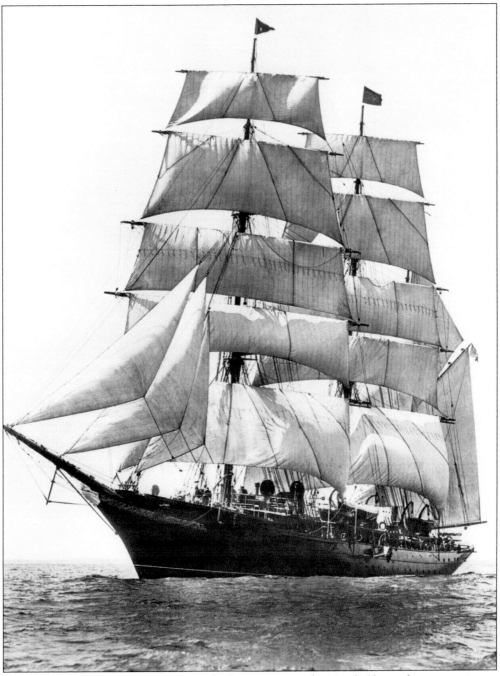

Although Arthur Curtiss James never had an estate on the North Shore, despite serving as commodore of both the Seawanhaka Corinthian and New York Yacht Clubs, he was often there aboard his great *Aloha* sailing yachts. The first, a 130-foot brig built in 1900, was replaced in 1909 by the magnificent 218-foot, steel-hulled bark photographed above under full sail. (MS.)

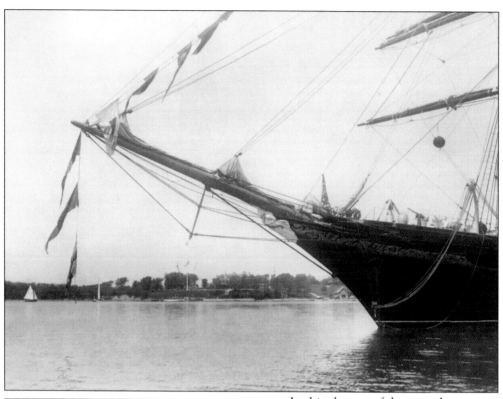

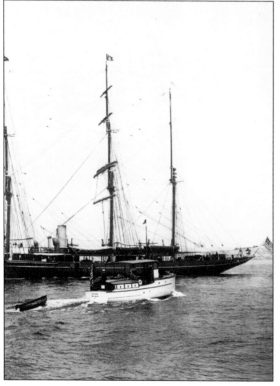

In this close-up of the second *Aloha*'s bow, she is seen moored in the Seawanhaka anchorage with the club dock and buildings in the background. The ship is "dressed" with the international code flags indicating a special occasion. James wished the figurehead of the first *Aloha* to be a likeness of his wife. When designer Clinton Crane paid a visit to the carver, he was aghast to see Harriet James portrayed in the nude and quickly ordered a draped version. (MM.)

In this view, the rest of *Aloha II* is visible. Designed by Clinton Crane of Tams, Lemoine & Crane, it was built at the Fore River Ship and Engine Building Company in Quincy, Massachusetts, in 1910. She carried a crew of 39 and an impressive 15,000 square feet of sail. *Aloha II* drew 16 feet and had to pick her anchorages carefully. A Navy patrol vessel on the East Coast during World War I, she was scrapped in 1938. (MM.)

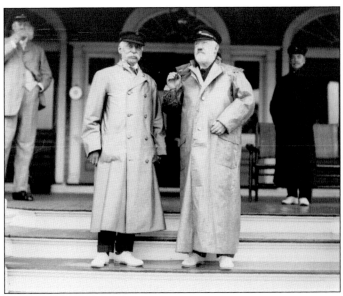

Commodore E.C. Benedict (1834–1920) of the Seawanhaka Corinthian Yacht Club, standing here to the right of his friend and business associate Colgate Hoyt, was a steam yacht sailor with wanderlust. Taking up yachting on doctor's orders in his 50s, the Wall Street financier cruised more than 275,000 miles on his yacht *Oneida*. One of his favorite destinations was the Amazon River, which he navigated for more than 1,000 miles upstream. (LC.)

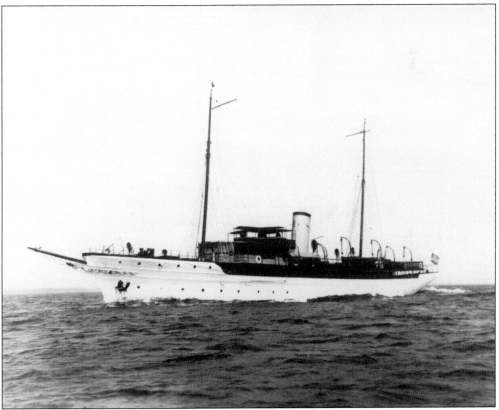

It was on board the first *Oneida* in 1893 that a secret operation took place to remove a cancerous lesion from the jaw of Benedict's good friend Pres. Grover Cleveland while cruising up the East River. Cleveland was such a frequent guest that *Oneida* once received a 21-gun salute by mistake on the assumption the president was aboard. In 1918, Benedict built the second *Oneida*, pictured above. After his death in 1920, the yacht was sold to William Randolph Hearst. (MM.)

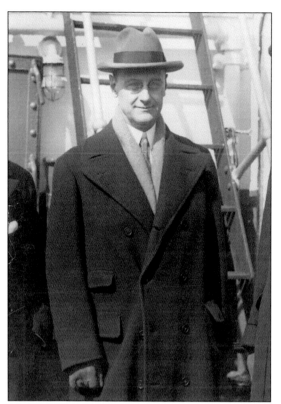

Ralph Pulitzer (1879–1939), publisher of the *New York World* and son of publishing mogul Joseph Pulitzer, had a country place at Manhasset where he was a member of the Manhasset Bay Yacht Club and owned a series of remarkable commuting yachts.

Kiluna Farm in Manhasset was designed by Walker & Gillette for Ralph Pulitzer and his first wife, Frederica Vanderbilt Pulitzer, around 1910. It is sited on one of the highest points along the North Shore, with views of Manhasset Bay and Long Island Sound. (HN.)

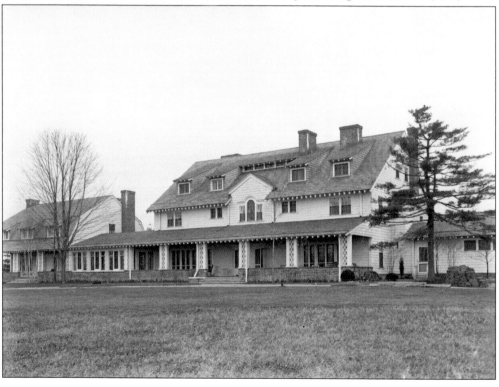

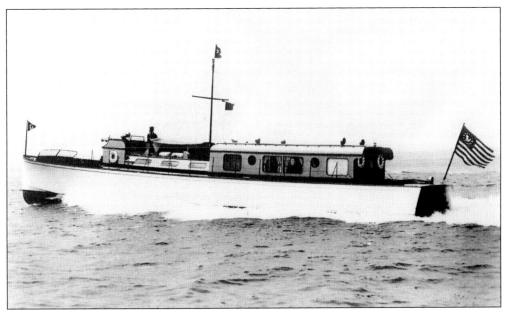

Ralph Pulitzer's first commuter, the 71-foot *Mystery*, was built by Luders during World War I and powered by Duesenberg gasoline engines. It was of the scout type favored by the government and suitable for antisubmarine patrols, if required. The Nevins-built *Phantom*, seen here, a sleek 66-footer whose Wright V12s made her capable of 45 knots, followed in 1927. (MS.)

Philip Le Boutiller's *Stormy Weather*, one of the most famous ocean racers of the 1930s, made her home in Oyster Bay. Winner of the 1935 Transatlantic and Fastnet Races, the 53-foot Olin Stephens–designed yawl was built by Nevins in 1934. (PC.)

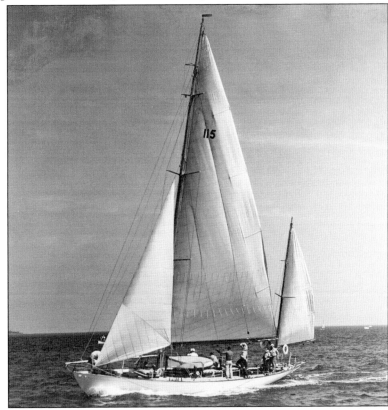

Harold S. "Mike" Vanderbilt (1884–1970), seen here with his wife, was the younger brother of Willie K. Born at Idle Hour, the Oakdale estate of his father, William Kissam Vanderbilt, he would never have a country house on Long Island Sound, inheriting Idle Hour in 1920. As a North Shore sailor, his list of sailing accomplishments, including three successful defenses of the America's Cup, would have no equal. Bright, intense, and capable, he attended Harvard and Harvard Law School, invented contract bridge, and helped revise yacht racing's rules. (MS.)

In his first *Vagrant*, the young yachtsman won the Bermuda Race in 1910 and continued his winning ways with the second *Vagrant*, the 109-foot Herreshoff steel-hulled schooner built in 1913. Mike Vanderbilt would race the big schooner, his flagship when he served as commodore of both Seawanhaka and the New York Yacht Clubs before and after World War I, gaining the experience which would later make him such a great America's Cup helmsman. (MM.)

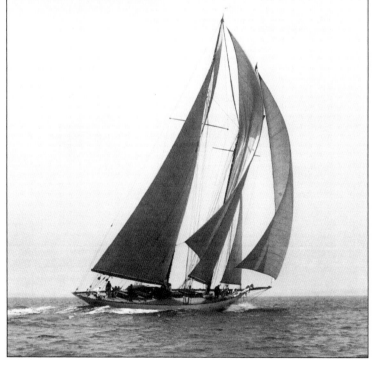

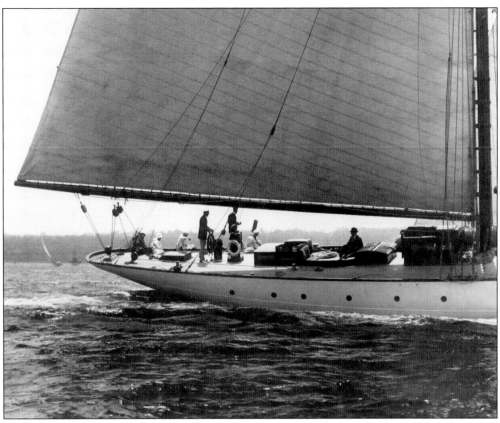

In this image of the second *Vagrant*, Vanderbilt is seen at the helm. Members of the afterguard, the decision-making yachtsmen in the owners circle, are formally attired, while the paid hands, often Scandinavians, are in the white sailor uniforms. (MM.)

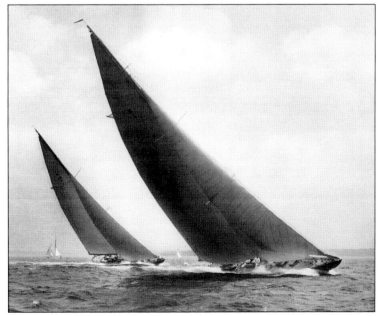

By the late 1920s, Mike Vanderbilt was racing in the new and very competitive M Class. In this iconic 1935 Morris Rosenfeld photograph, Vanderbilt's 80-foot sloop *Prestige* leads Junius S. Morgan's *Windward* in a race off Glen Cove. Junius, J.P. Morgan Jr.'s son, was also an avid yachtsman whose estate, Salutation, was on West Island at Glen Cove. (MS.)

Vara, Mike Vanderbilt's 150-foot motor yacht built by Herreshoff in 1928, would also be in naval service during World War II as the USS *Valiant*. (MS.)

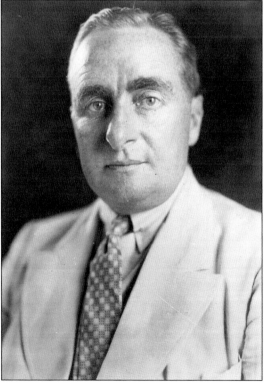

Ogden L. Mills (1884–1937), who replaced Andrew Mellon as secretary of the treasury during the Hoover administration, was a politician who served in Congress and ran against Al Smith for governor of New York in 1926. (AC.)

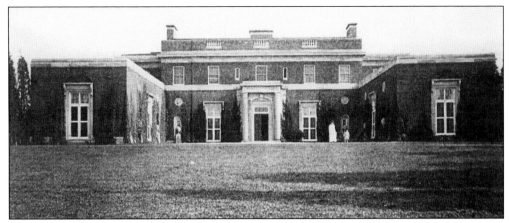

John Russell Pope designed Ogden Mills's handsome Woodbury residence in the Adamesque style about 1915. The unusual H plan employed by Pope amplified sunlight and the house was cleverly situated so there were views in all directions. It later became the Woodbury Country Club. (HML.)

Dorothy Randolph Fell Mills christens *Avalon* on March 14, 1931. (HML.)

Avalon, Ogden L. Mills's 180-foot, diesel-powered motor yacht, was designed by Cox & Stevens and built by Pusey and Jones in 1931. Mills would make use of the beautiful yacht for just six years before his untimely death at 53 following a cruise from his home club, the Cold Spring Harbor Beach Club, to Newport in 1937. (HML.)

Avalon under way was a pretty sight. She was one of 15 American yachts acquired by the Canadian government in 1940 and, as the HMCS *Vision*, was involved in antisubmarine patrols during World War II. (AC.)

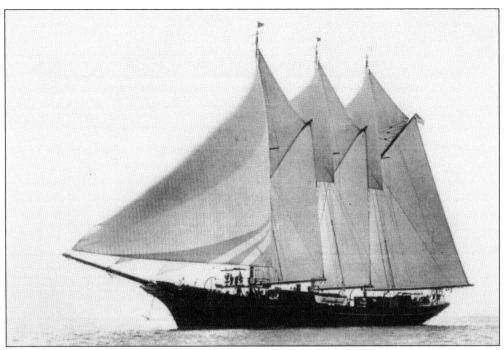

Hussar IV, Edward F. Hutton's 202-foot, three-masted schooner, was designed by Cox & Stevens and built in 1923 by Burmeister & Wain, the Copenhagen yard. Hutton had married Marjorie Merriweather Post three years before, and she soon became as avid about yachting as her husband. (PC.)

Pictured here is *Hussar IV*'s handsome bowsprit. (PC.)

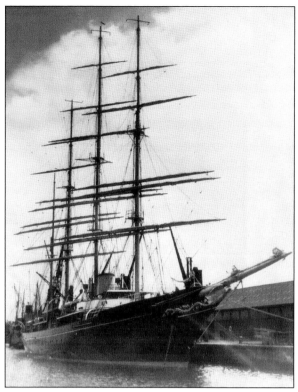

Hussar V, the huge 316-foot, four-masted bark built in Germany between 1929 and 1931 for the Huttons, was the largest sailing yacht ever constructed and perhaps the ultimate pleasure craft of this era of elegance. A world traveler, she was rarely seen on Long Island Sound and is pictured here in 1938 while docked at Southampton, England. (AC.)

After World War I, when her home port was Larchmont, the great bark, which had been renamed *Sea Cloud*, was seen in local waters. The Larchmont race fleet encountered her one afternoon in the early 1950s under full sail between Matinecock Point and Rye. A deck officer with a large megaphone requested all small craft to stand clear, reporting that "we are about to tack ship (change direction) if we can." (AC.)

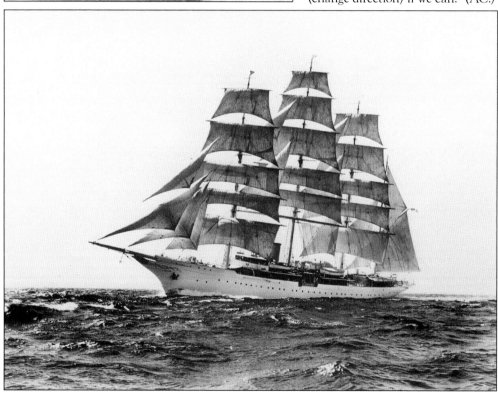

Hutton had previously owned four yachts of the same name. A member of the New York Yacht Club, he urged friends to keep their large yachts in commission during the Depression to provide employment. However, this *Hussar* was to be Marjorie's project from the outset. During the planning phase, she rented a Brooklyn warehouse to chalk out on the floor all the cabin arrangements. (AC.)

Hillwood, the Huttons' Brookville residence (1921–1928) was a perfect expression of the "Stockbroker Tudor," that favored design idiom of its age. The rambling, picturesque country house with a marvelous topiary garden, by Marian C. Coffin, stayed with Marjorie after the divorce. She sold it to the Long Island University for their C.W. Post campus in 1951. (NLH.)

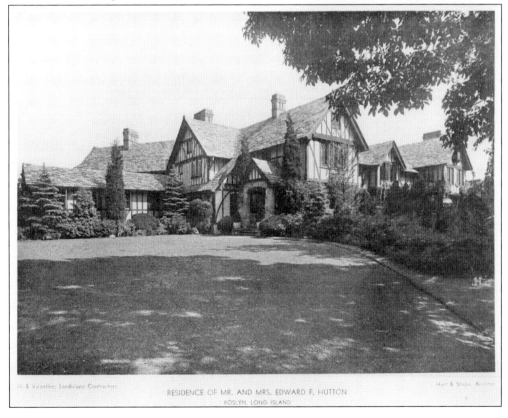

RESIDENCE OF MR. AND MRS. EDWARD F. HUTTON
ROSLYN, LONG ISLAND

When the Huttons divorced in 1935, Marjorie married Joseph E. Davies but held onto the *Hussar*, which she had helped plan, renaming of the huge yacht to *Sea Cloud*. In naval service during World War II, *Sea Cloud* was thereafter returned to the Davies. Sold to the Dominican dictator Trujillo in 1955, *Sea Cloud* fell into sad shape after his assassination but survived. In the 1970s, she was converted into a cruise ship at the same yard that had built her almost half a century earlier. (AC.)

Mortimer L. Schiff (1877–1931), the investment banker and philanthropist who was an ardent supporter of the Boy Scouts of America, was among the leaders of finance who were discovering the North Shore at the beginning of the 20th century. He was a member of the New York Yacht Club and in the 1920s owned both a large motor yacht, *Dolphin*, and the 73-foot consolidated commuter *Dolphin II*. (AC.)

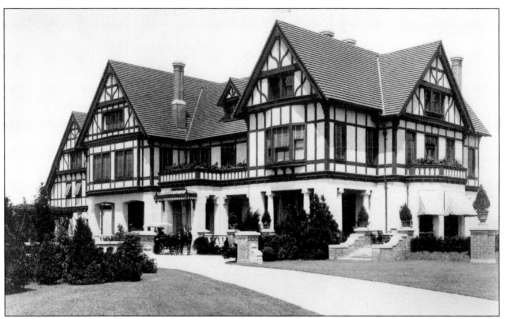

Northwood, Mortimer L. Schiff's estate at Oyster Bay, was not far from the water. C.P.H. Gilbert designed a country house for the investment banker in the Tudor style that was complete by 1906. (PC.)

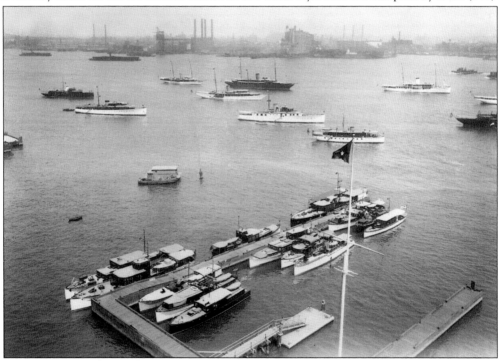

Dolphin, Schiff's 181-foot diesel motor yacht, was designed by Cox & Stevens and built in 1922 by the Newport News S.B. Co. She was used both for commuting and cruising and is seen here anchored in the East River (white hull, upper right) off the New York Yacht Club's landing for commuters. Among the American yachts sold to the Canadian government in 1940, *Dolphin* became HMCS's *Lynx* during World War II. By the mid-1950s, she was a fruit ship in the Caribbean. (MS.)

DISCOVER THOUSANDS OF LOCAL HISTORY BOOKS
FEATURING MILLIONS OF VINTAGE IMAGES

Arcadia Publishing, the leading local history publisher in the United States, is committed to making history accessible and meaningful through publishing books that celebrate and preserve the heritage of America's people and places.

Find more books like this at
www.arcadiapublishing.com

Search for your hometown history, your old stomping grounds, and even your favorite sports team.